Folk Art and Tole Painting

MILNER CRAFT SERIES

Folk Art and Tole Painting

NEW DESIGNS FOR DECORATIVE PAINTWORK

KATE COOMBE

SALLY MILNER PUBLISHING

First published in 1992 by
Sally Milner Publishing Pty Ltd
558 Darling Street
Rozelle NSW 2039 Australia

Reprinted 1992 (three times), 1993 (twice)

© Kate Coombe 1992

Design by David Constable
Layout by Gatya Kelly, Doric Order
Photography by John Knight
Typeset in Australia by Asset Typesetting Pty Ltd
Printed in Australia by Impact Printing, Melbourne

National Library of Australia
Cataloguing-in-Publication data:

Coombe, Kate.
 Folk art and tole painting.

 ISBN 1 86351 057 5.

 1. Tole painting. 2. Painting – Technique. 3. Folk art. I. Title.

745.723

CONTENTS

ACKNOWLEDGEMENTS

I would like to thank all my friends and students who gave me such terrific support and encouragement while this book was being put together. A special thanks to Denise Little for her pictorial support, John Knight for the photography and my children for giving up their school holidays for the production of this manuscript.

I would also like to acknowledge the following businesses, and thank them for their support and supplies:

Chroma Acrylics, Ku-ring-gai NSW
 (02) 457 9922, (008) 02 3935

Artisan, Fyshwick ACT
 (06) 280 6673

Country Folk Art Connection, Woodend VIC
 (054) 27 1267

The Folk Art Studio, Fairlight NSW
 (02) 949 7818

Easycraft, Artarmon NSW
 (02) 439 7321

Kate Coombe, 1992.

HISTORY OF FOLK ART

Once upon a time all art was decorative. The separation of painting and sculpture into 'fine art' and most other forms into 'the decorative arts', with the implication that the latter somehow suffered by comparison, occurred with the rise of modern art. Today's revival of interest in the decorative arts in general and folk art in particular shows a cheerful rejection of that separation. Most people are showing a great appreciation and enjoyment of many forms of decoration and see folk art as a genuine art form. I believe the rise in popularity of folk art (used as a general term for all painted decoration) is occurring because it is an art form that is available to everyone. The techniques can be acquired by just about everyone and the skill and artistry occur with practice and the use of the designs by each individual.

The history of folk art could be said to cover the cave paintings in France as well as the painted sulky your great grandfather owned. The folk art that is the source for the modern version is generally the European handpainted decoration that occurred on houses, furniture, metalware, pottery (porcelain and earthenware) and any useful wooden items, just after the Middle Ages. The most interesting aspect of folk art is the way each European nationality developed its own style of painting and how its use was translated into specific areas. Thus the Scandinavian countries became renowned for their decorated houses, the Dutch for their blue and white earthenware, the Austrians and later the Germans and the Swiss for their elaborate

furniture, the French for their Limoge porcelain and tinware (which is where the term Tole Painting comes from — tôle peinte being French for 'painted tin'), the Russians for their icons and the English for their barges and their decorative wooden plates. This is not to say that the Scandinavians did not paint their furniture, the Dutch their houses, the French their earthenware, the Russians their tin or the English their porcelain — quite the contrary — they all saw this art form as something to be practised and enjoyed by anyone who felt so inclined. The German word for folk art, 'Bauernmalerai', which literally means 'farmer painting', is a clear indication of its democratic beginnings. The modern interpretation of the term 'Bauernmalerai' has come to incorporate many varied and extremely elaborate styles of decorative painting. It is these exotic florals and imitation wood grain finishes that are creating a lot of interest today.

With the arrival of the 'modern' era and the influence of the Bauhaus as a centre of design in the early 1900s painted decoration (particularly on furniture) was cast into disfavour. In spite of the lack of painted furniture after World War II many of the American servicemen's wives returning to the USA brought with them the decorative painting styles they had seen in European houses. America already had a tradition of decorative painting with the Pennsylvania Dutch and French settlers which was referred to as Tole Painting, so the modern American decorative artists used source material from their European background as well as creating new styles to fit their own 20th Century culture.

The year 1992 marks the 20th Anniversary of the formation of the largest American group of decorative painters, the NSDTP, or The National Society of Tole and Decorative Painters, which has in excess of 35000 members. The growth of this group in just twenty years is a clear indication of how appealing the art form is.

The interest is widespread and those of us who already practise folk art, find it the most enjoyable, relaxing and absorbing activity. It creates a wonderful group of friends from a series of casual acquaintances and brings out the creativity in all of us. Each painter has his or her own unique style and although the designs we use are the same, the finished item invariably has the stamp of its painter that makes it one of a kind. Gradually, I hope, we will develop folk art styles that are of particularly international appeal and decorative painters will continue to exchange styles, patterns and ideas around the world.

Kate Coombe

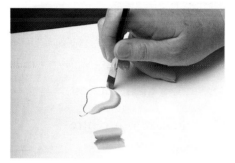

Step A:
Using a shape-following stroke with a flat or round brush

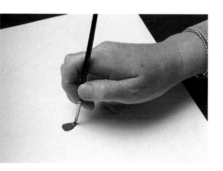

Step B:
Blend two colours on the brush for wet-on-wet technique

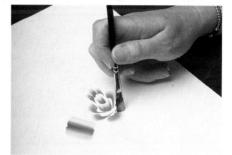

Step C:
Double load a flat brush for the stroke rose

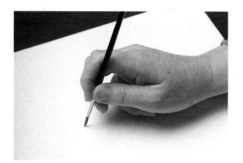

Step D:
i. Place the point of the paint-loaded brush on the surface

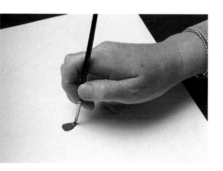

ii. Press down and push the handle forward to flare the bristles

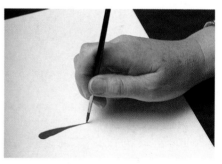

iii. Pull the brush towards you while lifting the brush back onto its point

Step E:
i. Dip one corner of a wet brush into paint

ii. Blend on palette by brushing backwards and forwards until paint merges across the brush

iii. Paint a shape-following stroke with colour to the outside

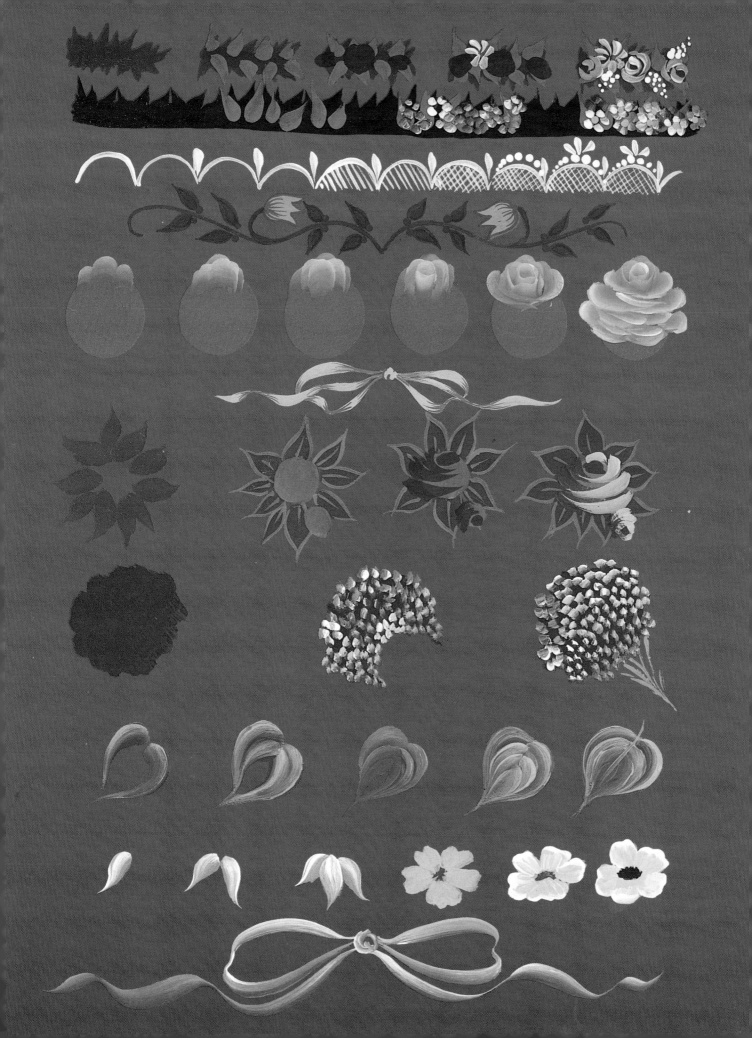

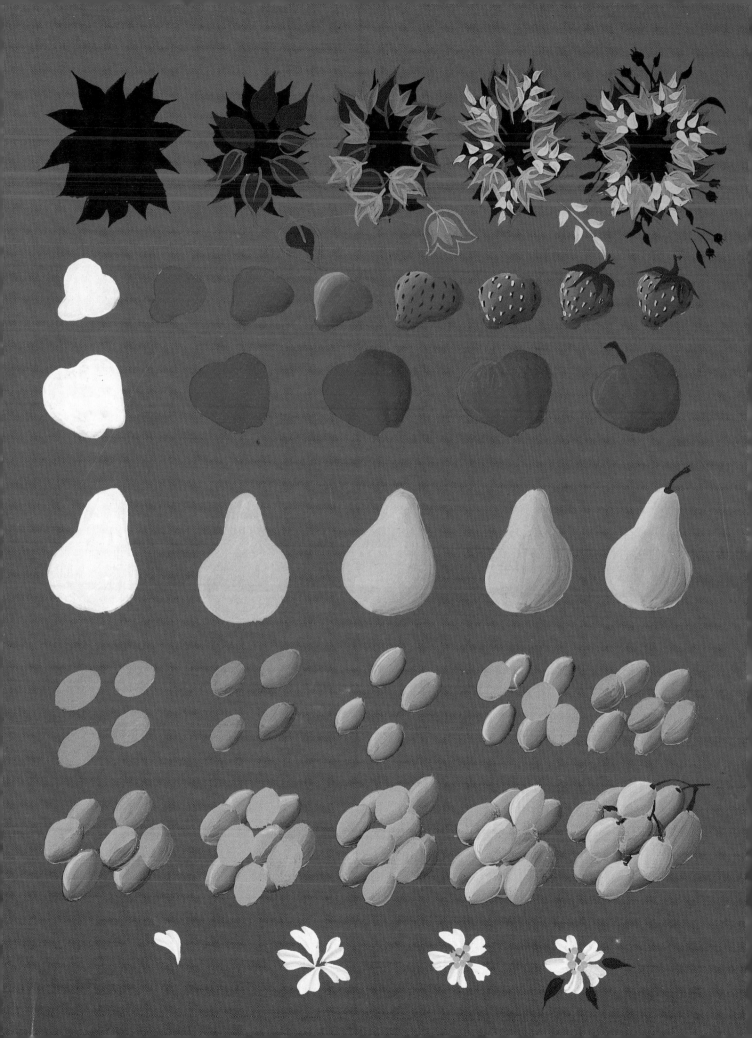

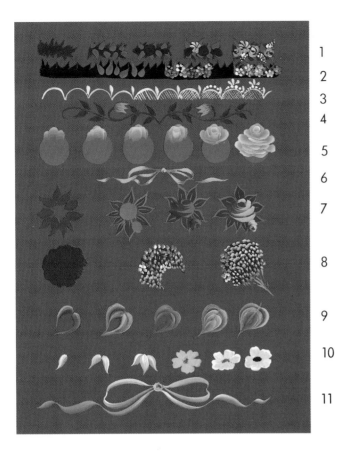

1 Steps for Rectangular Frame
2 Steps for Large Rectangular Frame
3 Lace for Square Frame
4 Sprays for Sheep Shelf
5 Stroke rose for Bedside Cabinet
6 Ribbon for Sheep Shelf
7 Rose clusters for Frames and Hanging Pot
8 Pom pom flowers for Bedside Cabinet
9 Leaves for Strawberry Dipper
10 Mini tulips for Bedside Cabinet, and
 poppies for Clock and Watering Can
11 Bow

12 Steps for freehand foliage
13 Strawberries — shading and highlighting
14 Apples — shading and highlighting
15 Pears — shading and highlighting
16 Grapes — three values, shade and highlight
17 Blossom for all fruit patterns

KEY TO PAINTED SAMPLERS FROM PREVIOUS TWO PAGES

GETTING STARTED

The general steps for reproducing the paintings in this book are as follows. Prepare your item according to the surface instructions, including basecoating, trace the pattern of your choice and apply it to your piece, then proceed to follow the instructions as directed for the individual painting.

The pieces I have painted for this book have been a mixture of 'found' metal and wooden items that I have picked up from old sheds, from clearing sales, and from second hand shops. I have also painted some new wooden pieces.

PREPARATION OF DIFFERENT SURFACES

There are several metal pieces in this book as well as wood and terracotta. Each surface needs a different preparation. The following steps are the ones I use most often.

METAL

If the metal is old and rusty I find it is worthwhile spending an extra $10 or $20 to have it sandblasted and primed before I basecoat it in my chosen colour in flat enamel paint. The hours you would spend with a wire brush and rust-proof paint could be spent painting! It has also been my experience that the best base coat for metal is flat enamel paint. Acrylic base coat applied straight onto the metal tends to lift at the slightest knock. Even enamel base coat is very fragile until it is decorated and varnished. The easiest paint to use is the aerosol flat enamel. It is expensive if you do a great many metal pieces and not environmentally very sound if you cannot obtain the right aerosol, but if you are only going to be doing the odd piece it certainly saves on turps and brushes.

If the metal is new, check it carefully. On some galvanised metal the galvanising process can leave a faint greasy residue that will not accept any base coat. This has to be cleaned off first with vinegar then the metal piece painted with Jo Sonja All Purpose Sealer and dried in the oven at 200°F (90°C) for ten minutes. Then you can basecoat the metal with the enamel paint.

TERRACOTTA

Most terracotta pots are once-fired earthenware which is porous — that is, it absorbs and retains water for a certain length of time. It is this quality that makes terracotta ideal for soil and plants but not very good for layers of decorative paint. If you wish to decorate the porous clay pot it must be sealed inside *and* outside. If it is only sealed on the outside the moisture in the soil will push the decoration off the pot, and if only the inside is sealed then the water in the paint will be sucked into the clay, causing the brush to drag and make stroke work difficult. Jo Sonja All Purpose Sealer is particularly good because it doesn't make the surface too shiny. I also use the Jo Sonja All Purpose Sealer as a varnish for terracotta because of its durability.

WOOD

Raw wood needs to be sealed and base coated. The easiest way to do this is to combine Jo Sonja All Purpose Sealer with the base coat colour and paint onto the wood with two coats, sanding between each coat. Another advantage of sealer in the base coat is that you can handle the base-coated piece without it absorbing any moisture or grease off your hands.

DRYING TIMES

Before you can add another layer of paint over your first coat of acrylic, there is a brief pause needed. If you attempt a second coat too soon the original layer will pull up or streak.

When you have finished a piece it is possible to varnish as soon as it is touch dry but it is much better to allow a few days CURING time for the paint before you varnish.

GENERAL SUPPLIES

PAINT

I have used Jo Sonja Artist's Colours in this book and have found them excellent. For those of you who have access to, or prefer, bottled or other brands of acrylic

paint, I have provided a colour conversion chart at the back of the book. Those interested in acquiring Jo Sonja Artist's Colours can contact the following suppliers:

Australia
Chroma Acrylics (NSW) Pty Ltd
Mt Ku-ring-gai, New South Wales
(02) 457 9922
(008) 02 3935

USA
Chroma Acrylics Inc
Hainesport, New Jersey
(609) 261 8500

UK
Thomas Seth & Company
Hartley, Kent
(474) 70 5077

NZ
Draw Art Supplies
Auckland, New Zealand
966 4862

Although it may seem that I ask you to mix quite a number of colours, I feel this is easier and more economical than referring to a vast range of various colours in a number of brands. You might notice I sometimes refer to Titanium White and Warm White. If I am specific and state the colour, it means that particular shade is best but if I just refer to White, it means you may use either Warm White or Titanium White.

BRUSHES

The brushes you use are very important and are probably the most expensive item in your whole kit of supplies. I use a 1″ synthetic brush for all base coating and varnishing. For stroke work and decorating I use a No. 2 or No. 3 and a No. 5 round synthetic brush, a No. 4 and a No. 8 flat brush and a No. 00 Long Liner. A clean, well-cared-for brush will last longer and give you better strokes with less effort than a brush with dried paint in it. It is most important to be very particular about always washing the paint out of the brush totally — either between colours or between painting stints. It is also a sensible economy to work

some brush cleaner or detergent into your brush after you have finished a painting session and before you give your brushes a final wash.

MISCELLANEOUS SUPPLIES

Other items besides brushes and paints that will be useful to you will be:
a stylus
transfer paper (light and dark)
tracing paper
medium and fine sandpaper
Jo Sonja All Purpose Sealer
Jo Sonja Retarder and Antiquing Medium
Jo Sonja Glaze Medium
a hair dryer
paper towel

TERMS AND TECHNIQUES
OF FOLK ART

LOAD THE BRUSH

This means putting paint on the brush!

SIDELOAD

Once you have loaded the main colour into the brush, touch one side of the point of the bristles into the edge of the side load colour. You should end up with a 'fingernail' of extra colour on the tip of one side of your brush. Keep this colour uppermost on your brush if you want it to appear at the beginning of your stroke or underneath your brush if you wish this colour to appear at the end of the stroke.

DOUBLE-LOAD

Load your brush with one colour, then poke the tip of the bristles into the second colour and paint your stroke. The second colour will appear the strongest and a blending with the original colour in the brush will appear at the end of the stroke.

BASE COAT

This refers to painting the object or an area of the design with a smooth even coverage so that it becomes an opaque single colour. Allow this to dry completely (unless the instructions refer to work for 'wet-on-wet') before you apply extra colour or strokes.

HIGHLIGHT

This refers to a lighter colour of the base coat which you apply to an object to make it appear three dimensional. The highlight is always on the opposite side to the shading colour.

SHADE

I use most of these terms as both a verb and a noun so when I tell you to shade the pear it means to apply a colour darker than the base coat of colour. This would be a darker 'shade' of yellow in the case of pears.

FLOATED COLOUR

Wet a flat brush and wipe out the excess water. The brush should be wet but not dripping. Sideload the brush by dipping one corner into the paint, then stroke the brush back and forth on the same spot on the palette until the paint gradually moves across the bristles. Move to the painting and place the edge of the brush with the most paint on, on the outer line to be shaded or highlighted. Paint a shape-following stroke. To reload, rinse the brush thoroughly and repeat the process.

WET-ON-WET TECHNIQUE

This is another form of highlighting and shading that I like to use, especially for larger areas. Touch the brush in Jo Sonja's Retarder before you paint the last layer of base coat, then, before this coat dries, pick up some shading colour in your brush and paint a shape-following stroke, blending the inner edge of stroke into the base coat.

COMMA STROKE

This stroke is just about the most basic and important stroke in all folk painting. It is being able to control the shape of this stroke, that is, getting the fat-to-thin-line of the comma stroke, that opens the doors to so many other painting techniques. The secret for me is in the bounce of the brush and how you control it. Load your round brush with paint of a flowing consistency and touch the point to the painting surface. Press the metal ferrule of the brush (the part that covers the end of the bristles and the wooden handle) towards the surface whilst bringing the handle upright to form a right angle with the surface. This will make the bristles flare and create the 'fat' part of the comma. At the same time as you are creating the shape, start pulling the brush towards you and gradually lifting the bristles off the surface so they return to a point. The 'bounce' is in that pressing down and lifting up to a point so that you can make your stroke as wide or as thin as you require to create the shape. The simplest rule is 'perfection requires practice': the more you paint; the better you get!

PUSH-DAB FLOWERS

These flowers are usually five petalled little numbers that are generally painted with a liner brush or a long round brush. They are made by placing a double-loaded tip of the brush on the piece and pushing the brush away from you slightly, then lifting off abruptly, leaving a tiny circle with both colours in it. Do five of these in a circle, keeping the colours facing the same direction each time.

DRY BRUSH

This is a technique which is used to apply small amounts of paint to create fuzzy areas. It is usually used for highlighting and involves wiping most of the paint out of the brush and lightly stroking the area you wish to be coloured with the brush, making soft fuzzy lines.

ROUGH BRUSH

This is a term I use to refer to an area of painting that has a solid centre but the edges are brushed out roughly so they are all hairy and soft. It is often a good way to create a soft dark background on a small area on which to layer flowers or fruit. When you brush out the edges, use a dry brush that has most of the paint wiped out of it.

ANTIQUING

There are two forms of antiquing. One uses water-based products, the other oil-based. I generally use the oil-based method and will give you the steps for that, but if you prefer to work with the water-based products, the Jo Sonja's Tech Data Booklet, available from any Jo Sonja Artist's Colour stockist, has complete instructions for a number of methods that are all satisfactory.

Oil-based — After your painting is completely dry, rub the whole area with a medium of six parts of gum arabic turps to four parts of boiled linseed oil mixed together. This should only be a light coat — just enough to seal the area, not dripping from the edges. Then put a touch of Burnt Umber Artist's Oil Paint on a rag and rub it onto the areas of your work that need to be shadowed. If you like the painting to be really dark, then rub the entire piece with oil paint, then rub it off only in the highlight areas. If you decide there are areas of oil paint you need to remove completely, then put some more medium on your rag and rub the Burnt Umber off. Give this layer a few days to dry — the time will vary with the temperature and the humidity — and then proceed with the varnishing.

SPONGING

Using a small sponge, a scrunched up rag or a paper towel crumpled into a ball, dip one corner or small section into one colour, then turn the 'sponge' and dip into another colour and again if you need more colours. Press the sponge onto the palette to get rid of the excess paint, then 'bounce' the sponge onto the surface of the piece to be decorated. As you bounce, move from area to area, turning the sponge this way and that so a variety of colours appear next to one another. You may leave the base coat showing through slightly, or cover it completely.

FLOWER PROJECTS
FRAMES

LARGE RECTANGULAR FRAME

PALETTE

Red Earth

Warm White

Teal Green

Green Oxide

Turner's Yellow

Burgundy

PREPARATION

Base coat the frame in a light mix of Red Earth and Warm White (just a touch of Red Earth mixed with a little Jo Sonja All Purpose Sealer). Allow to dry. I have given you the pattern, but it would be tedious to transfer so I think you should just refer to the photograph and freehand the pattern as you paint it.

PROCEDURE

1. Using a No. 3 round brush, rough brush in a Teal Green stripe by painting a flat green stripe first, then with as little paint in the brush as possible (without actually washing the brush) brush out the edges of the stripe unevenly so the effect is that of a rough hairy green rope down the middle of each side.

2. Pick up Green Oxide with the liner brush and dab some baby comma strokes to create a layer of small lighter green leaves. Refer to the photograph for placement.

3. Base in circles of Burgundy in each corner and some small ovals on either side of each circle. Mix some White and Burgundy together to make a medium pink, then with this pink in the brush and a side load of White, paint small curved comma strokes around the circles and ovals, leaving a tiny dark circle for the throat of the rose. Try to keep the White side loading to the centre of the rose, or towards the throat on the buds.

4. Still using the liner brush, now loaded with Turner's Yellow and sideloaded with Warm White, paint a daisy with a circle of small curved comma strokes on either end of each corner motif. When these are dry, dab in an oval centre.

5. Finally, using a stylus, skewer or sharpened pencil, dot in little sprays of Baby's Breath in all the appropriate spaces between the flowers you have already painted, with reference to the photograph for shape and position. Allow to dry and cure, then varnish with several coats of satin water-based varnish.

RECTANGULAR FRAME

PALETTE

Red Earth	Ultramarine	Black
Warm White	Jade	Yellow Oxide

PREPARATION

Base coat the frame in Red Earth mixed with a little Jo Sonja All Purpose Sealer and allow to dry. Paint the outer sides of the frame Black. I have given you the pattern, but it is small and detailed and will be difficult to transfer. Refer to the photograph and freehand the pattern on as you paint.

PROCEDURE

1. Paint some black comma stroke leaves in towards the centre of the frame, commencing on the outer edge and joining the base of the leaves with the Black sides. Use the liner brush if you would like finer leaves.

2. Change the colour to Jade and add a layer of smaller comma stroke leaves in a random layer on top of the black leaves.

3. Load the liner brush with French Blue and sideload with Warm White. Paint in 'dab' flowers over the jade leaves with clusters of flowers in each corner. These five-petal little flowers are made by pushing the side-loaded tip of the brush away from you slightly, then lifting off abruptly, leaving a tiny circle with both colours in it. Do five of these in a circle. Place them with reference to the photograph.

4. Dot Yellow Oxide in the centre of each flower circle. Allow to dry and cure, then varnish with several coats of satin water-based varnish.

SMALL SQUARE FRAME

PALETTE

Warm White Burgundy Green Oxide

Teal Green Red Earth

PREPARATION

Base coat the frame in a terracotta colour which is a mix of Warm White and Red Earth. Allow to dry. The pattern for this frame is included in the book, but it is easier to freehand as you paint it, with reference to the photograph, rather than transfer such tiny outlines.

1. **Roses** — Base in a cluster of Teal Green leaves in each corner of the frame. Use a liner brush if you cannot get small enough leaves with a No. 3 brush. Outline the leaves with Green Oxide on the liner brush and paint in some fine wriggly lines as tendrils — refer to the photograph for placement. Mix a little Burgundy and Warm White to make a medium pink and base in a circle and two small ovals in the centre of each leaf cluster. Now paint the roses with a round brush according to the steps on the instruction pages in the colour section of this book.

2. **Lace** — Divide the inner sides of the frame into equal spaces with a ruler, and with a liner brush and thinned Warm White, paint in the lace around the inner edge of the frame, again following the steps on the instruction page. Allow to dry and cure, then varnish with several coats of satin water-based varnish.

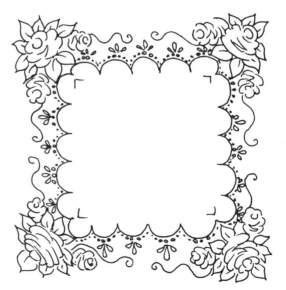

Small Square

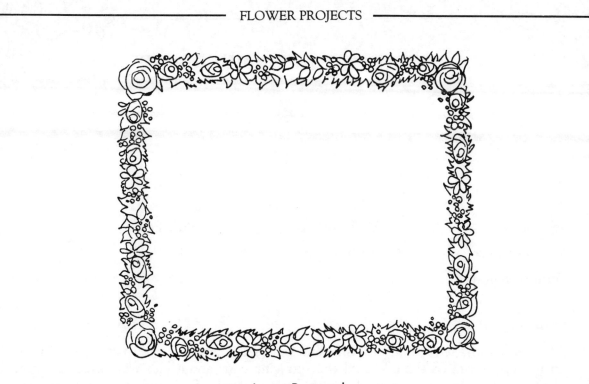

Large Rectangle

Rectangle

TERRACOTTA FLOWER POT

PALETTE

Teal Green

Yellow Oxide

Turner's Yellow

Warm White

Brown Earth

Plum Pink

Jade

PREPARATION

After sealing the terracotta pot inside and out (see 'Getting Started') sponge a border on the upper rim of the pot until the sponging ends about half way down the pot. Use a variety of greens for this. Allow to dry completely. Trace and transfer the pattern to the pot over the sponged border.

PROCEDURE

1. Double-load a No. 3 round brush with Jade and Warm White and paint in the leaves, large and small, with double comma strokes, making heart-shaped leaves.

2. Load the brush with Warm White and pick up a touch of Turner's Yellow and stroke in the daisy petals, as curved comma strokes, referring to the photograph as a guide. Allow to dry.

3. Paint in the oval daisy centres in Yellow Oxide. While the centre is still wet, load the brush with Yellow Oxide and sideload with Brown Earth. Paint a comma stroke on the lower side of the daisy centre, with the Brown Earth on the outside.

4. Using the liner brush loaded with Red Earth and sideloaded with Warm White, paint in the smaller daisies with small comma strokes. Using the same load, paint in the centres of these daisies.

5. Mix a little Yellow Oxide with some Jade, water it down, and, using the liner brush, paint in the stems for all the leaves and daisies as long slim lines. Allow to dry and cure and varnish with ceramic sealer as recommended in 'Getting Started'.

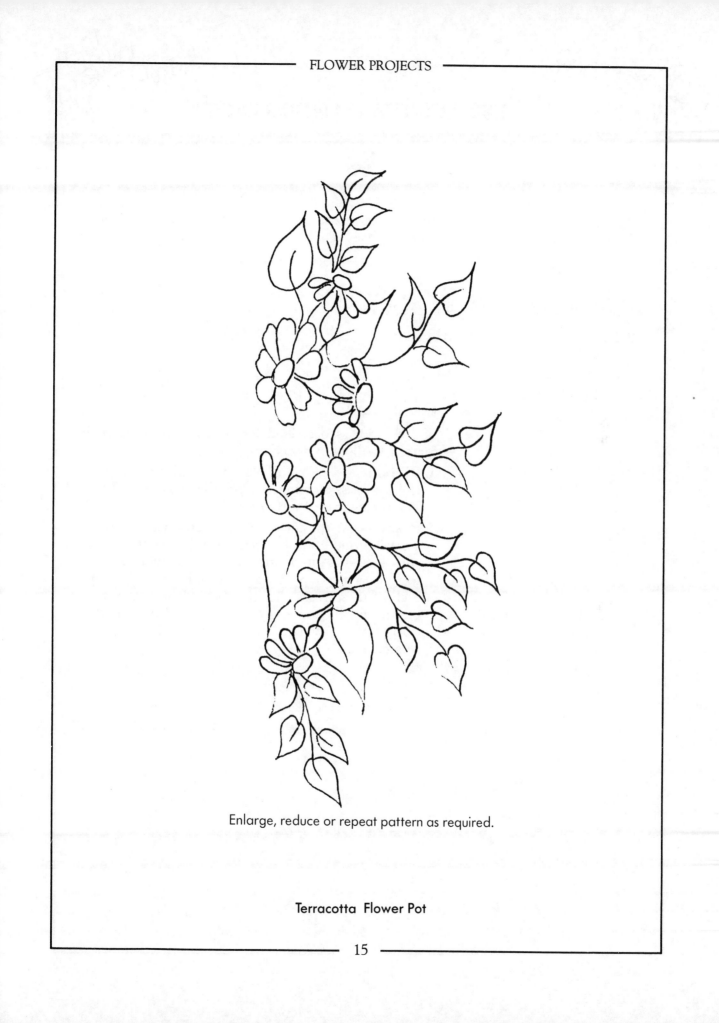

Enlarge, reduce or repeat pattern as required.

Terracotta Flower Pot

TERRACOTTA HANGING POT

No pattern has been provided for this particular piece as it is easiest to paint it freehand, referring to the photograph as a guide.

PALETTE

Warm White Turner's Yellow Jade

Plum Pink Burgundy Teal Green

Black

PREPARATION

Seal the pot as described for terracotta (see 'Getting Started'). Allow to dry completely.

1. **Ribbons** — Using a No. 5 round brush, paint ribbons criss-crossing around the pot with Warm White side loaded with Turner's Yellow.

2. **Roses** — At the intersection of each ribbon, paint a small group of Teal Green leaves and outline these with Jade. Base in a circle and one or two ovals on top of each group of leaves with Plum Pink. Paint each of these roses and buds according to the steps on the instruction pages in colour section of this book. Varnish the pot inside and out with ceramic sealer.

WATERING CAN

PALETTE

Plum Pink	Titanium White	Black
Gold Oxide	Pine Green	Yellow Oxide
Turner's Yellow	Teal Green	Norwegian Orange
Red Earth	Jade	Green Oxide
Ultramarine	Warm White	

PREPARATION

Base coat the metal watering can or item you are painting with Rustguard or any other rust proofing metal primer or enamel. Paint or spray with white or cream enamel paint. When this is dry, sponge a mixture of Teal Green, Green Oxide and Jade onto the base of the painting area so that the most Teal is at the lower edge and the colour blends through Green Oxide to Jade. (See Sponging in 'Terms and Techniques of Folk Art'). Allow to dry completely and apply the pattern.

1. **Foxgloves** — Using a liner brush and Pine Green, paint in the stems with a thin, slightly wobbly line from the bottom of the stems to the top. Add some large comma stroke leaves at the base of each stem. Change to a round brush, double-loaded in Plum Pink and Warm White, and dab variegated Plum Pink and Warm White flowers up and down the Pine Green stems. Change back to the liner brush and paint thin curved comma strokes in Pine Green as sepals on the back of each blossom. Allow the Plum Pink and Warm White to mix here and there, so there are stalks of dark pink and stalks of light pink flowers.

2. **Poppies** — Using a round brush and loading in various combinations of Gold Oxide, Warm White, Red Earth and Yellow Oxide so that the poppies are different shades of pink, red and gold, base coat each flower in the chosen mix. For each poppy mix, sideload lightly in White and repaint each petal with

the White on the top rim of each petal. You can paint each petal as a series of overlapping comma strokes with the rounded tips just touching into the prepainted white rim. Change to the liner brush and load in Pine Green mixed with a touch of Turner's Yellow and paint in the stems and leaves, referring to the photograph and the pattern.

3. **Daffodils** — Base the daffodils in Turner's Yellow with a round brush. When these are dry, add some Norwegian Orange to the Turner's Yellow and paint in the daffodil trumpets. Change to the liner brush and with Norwegian Orange, paint a narrow outline around the trumpet edge. Refer to the photograph to save you putting the pattern on again.

4. **Forget-Me-Nots** — Load the liner brush with Ultramarine Blue and sideload with Titanium White and place push-dab clusters of little flowers all around the base of the pattern. Refer to the description of these flowers in 'Terms and Techniques of Folk Art'.

Allow to dry and cure, then coat with several coats of satin water-based varnish.

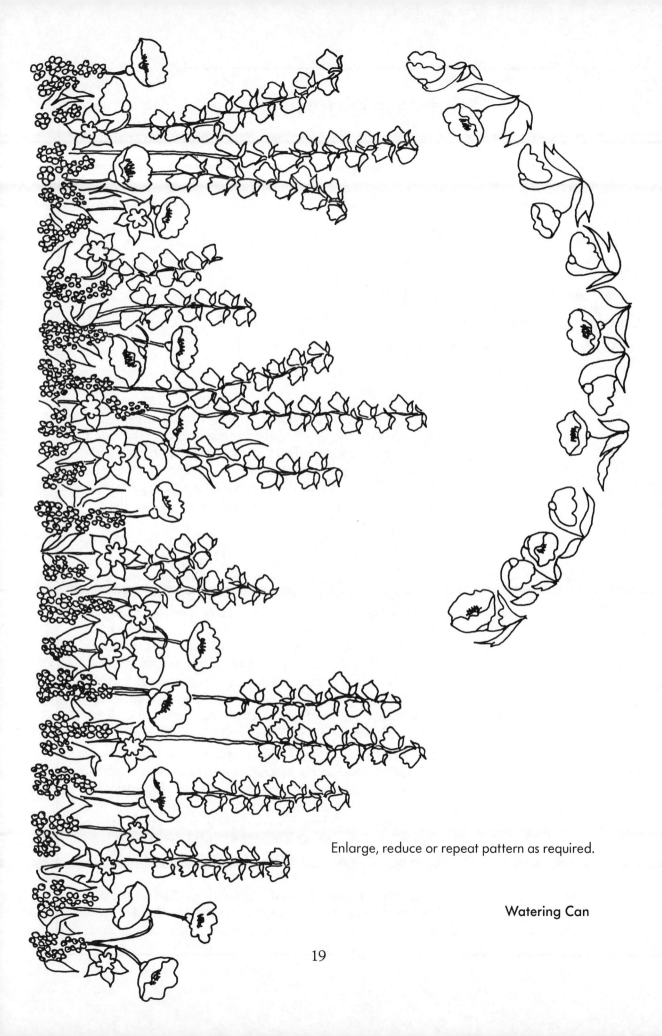

Enlarge, reduce or repeat pattern as required.

Watering Can

19

BEDSIDE CABINET

PALETTE

Red Earth	Jade	Yellow Oxide
Teal Green	Green Oxide	Titanium White
Storm Blue	Brown Earth	Jade

Cream (a mix of White: Raw Sienna: Yellow Oxide — 6:1:1)

Smoke (a mix of Red Earth: Storm Blue: White — 1:1:3)

PREPARATION

Base coat the cabinet door in Cream and the rest of the cabinet in Teal Green. For the sponged background use a combination of Teal Green, Green Oxide and Jade on a sea sponge. Sponge in an oval background to the bunch of flowers and if you have a large area of cream, sponge a border of the greens. Allow to dry and apply the flower bunch pattern.

1. **Leaves** — All the large leaves in the flower bunch are painted with a No. 5 round brush double-loaded with Teal Green and Green Oxide. Stroke in the pear-shaped leaves according to the instruction pages in the colour section of the book. The grub-shaped leaves (some of which are covered by flowers) are single strokes in Teal and Green Oxide. Draw a short line with the very tip of the brush before pushing down to flare the bristles and make a large curved comma stroke. The smaller foliage amongst the flowers can be left until after the daisies and pom-pom flowers are completed.

2. **Tendrils** — With the liner brush loaded in thinned Green Oxide, paint in long, wriggly fine line tendrils. Then pick up some solid Teal Green and paint in the little ivy leaves with triple short fat comma strokes, with their rounded ends overlapping. Keep reloading the brush alternately in Green Oxide and Teal Green as you work from tendril to tendril so there is some variety in the leaves.

3. **Tendril Flowers** — Mix a touch of Red Earth and Storm Blue with White to form Smoke (a grey-

mauve). Load a No. 2 round brush with Smoke and sideload in White, and paint in the tendril flowers with three comma strokes, overlapping their rounded ends to form a baby tulip. These are almost the same as the ivy leaves. I just lie the tulip comma strokes closer together and flare them less than the ivy leaf commas.

4. **Daisies** — Double-load a No. 3 round brush with Yellow Oxide and Turner's Yellow side load, and, using a series of short tailless commas, paint in the yellow daisies. The daisy centres are Raw Sienna with some pollen dots on the lower side in Brown Earth.

5. **Pom-Pom Flowers** — Using a No. 3 round brush, pat in a semi-circle of thinned Storm Blue on each of the pom-pom areas by putting down and lifting up the brush. The background should be quite splotchy. Then double-load a liner brush with Storm Blue and Titanium White and push-dab little flowerettes all over the based-in areas. These push-dab flowers are described in 'Terms and Techniques of Folk Art'. Try to make a push-dab stroke for each petal so that a touch of white is kept on the same side each time. Take these flowerettes just slightly over the edge of the based-in area.

6. **Roses** — These are flat brush roses (that is, they are painted with a No. 8 flat brush) which are coloured with a blended mix of Red Earth and Titanium White. First, base in a circle of Red Earth. Pick up Red Earth and White on opposite corners of a No. 8 flat brush and blend these colours by stroking backwards and forwards on the palette. When the brush is fully blended (that is, there is a gradual progression of dark apricot to pale pink across the brush) then follow the steps on the instruction pages in the colour section of the book to stroke in the roses. I would practise these first until you have the sequence memorised. I have put more petals on the larger roses than shown on the instruction pages, so if you wish to add more strokes on the last steps, do so. The main thing is to cover all the based-in area with rose petals.

Rosebuds — The rosebuds are just half-completed roses. Base-in an oval with Red Earth and with the flat brush and the same double-blended colours, paint in the first three or four steps, then leave some Red Earth showing. Change to a liner brush and stroke in the rose sepals and the stems in Teal Green.

7. **Small Foliage and Stems** — With a round brush and a mixture of lighter greens, paint in the smaller foliage between the finished flowers with various curved comma strokes. Use combinations of Yellow Oxide and Green Oxide, Jade and White and Green Oxide and Jade. The fronds are basically just filler strokes so there is no need to follow the pattern too closely. Paint the stems in a wash of thinned Green Oxide.

8. **Acanthus Flowers** — These sprays are painted with a round brush in a pale green made from a touch of Teal Green and Titanium White. Load the brush in the pale green and pick up a good quantity of Titanium White and, starting from the top of the spray, paint fat tailless comma strokes all the way down. Change to the liner brush and Teal Green and paint in fine little spikes at the base of each flower.

9. **Ribbon** — Double-load a No. 5 round brush with Red Earth and White and paint in the ribbon, using a thin-fat-thin stroke, starting with the brush up on its point then squashing down to flare the bristles then lifting back up on the point. The knot is two C-strokes with the brush double-loaded.

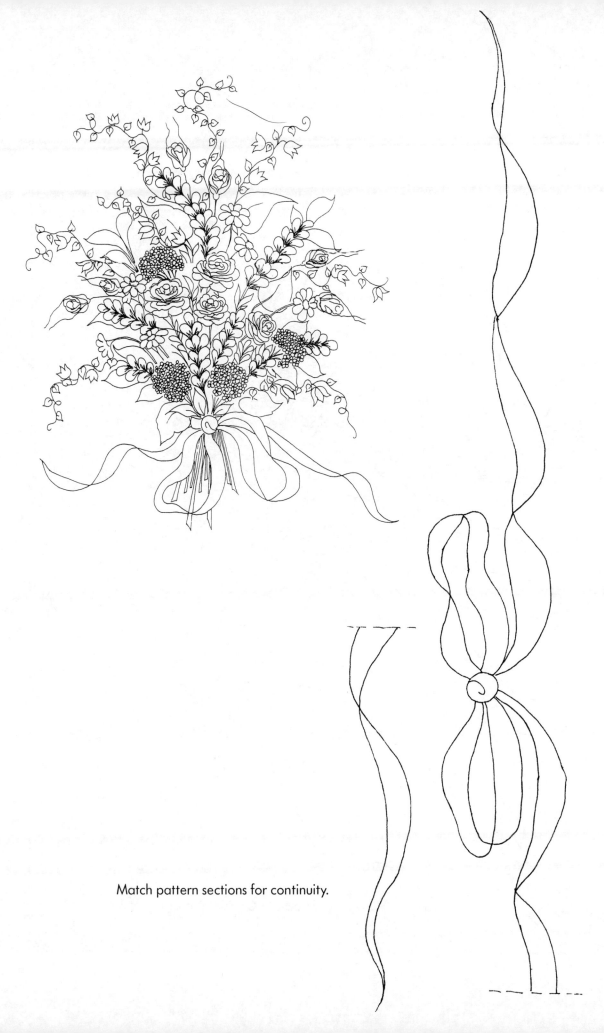

Match pattern sections for continuity.

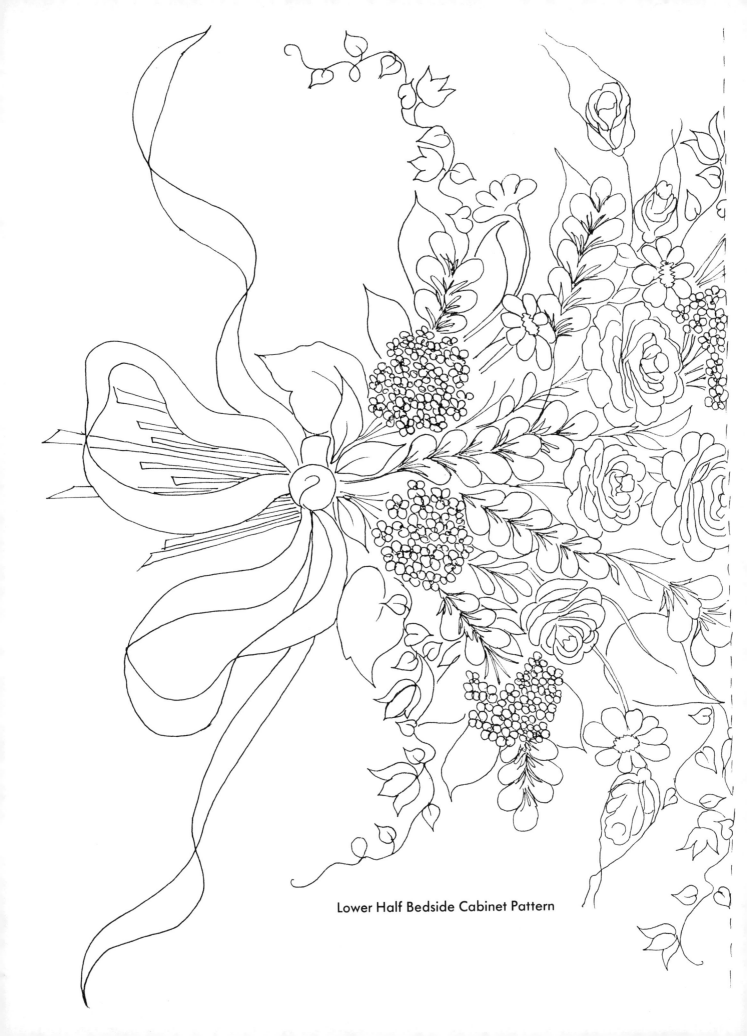

Lower Half Bedside Cabinet Pattern

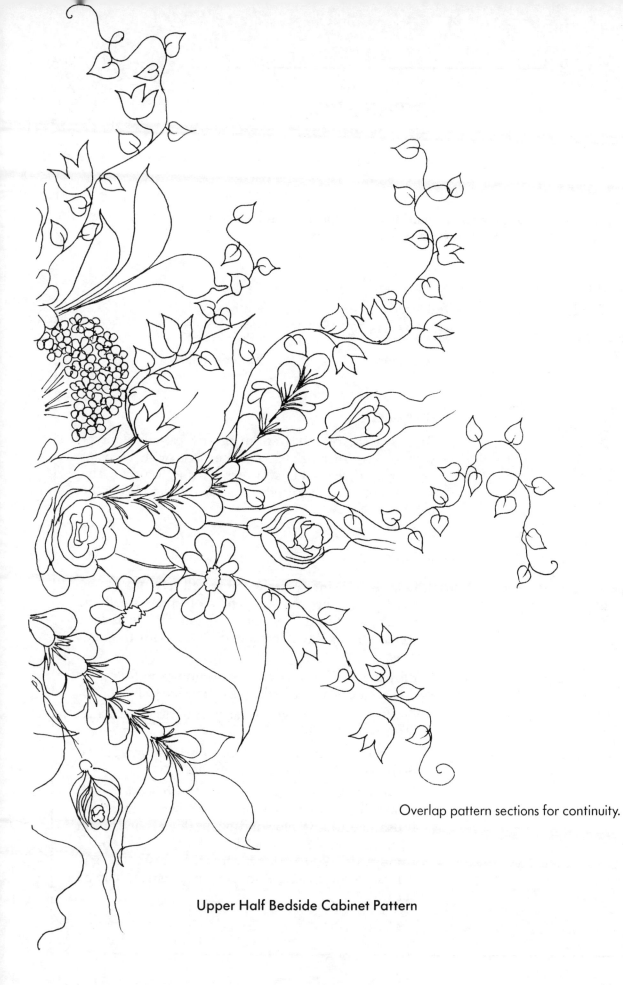

Overlap pattern sections for continuity.

Upper Half Bedside Cabinet Pattern

THE BED

I developed these patterns to suit any old iron bed and each spray of flowers can be painted on the front or back of the bed, or both.

PALETTE

Red Earth	Teal Green	Yellow Oxide
Storm Blue	Titanium White	Green Oxide
Jade	Raw Sienna	Turner's Yellow

PREPARATION

Base coat the bed in a cream or any pastel colour of your choice, then sponge the area you wish to paint with the three greens, in the same way as the background sponging on the bedside cabinet. Allow the paint to dry.

PROCEDURE

1. **Leaves**— Paint a series of small ivy leaves by overlapping the rounded ends of three small fat comma strokes in Teal Green. Paint the stems in a cream mix of Raw Sienna and White with the liner brush.

2. **Flowers** — The methods of painting the following flowers are all described for the Bedside Cabinet.

 Rosebuds — Use a No. 4 flat bursh with Red Earth blended with White.

 Acanthus — Shortened versions of the sprays on the Bedside Cabinet in Titanium White.

 Forget-Me-Nots — Use the liner brush loaded with Storm Blue and White and on the very tip of the brush dab in tiny blue and white flowers and finish with a Turner's Yellow dot in each centre. When the paint is dry, seal with an aerosol varnish. A spray varnish is much easier to use on a narrow curved surface.

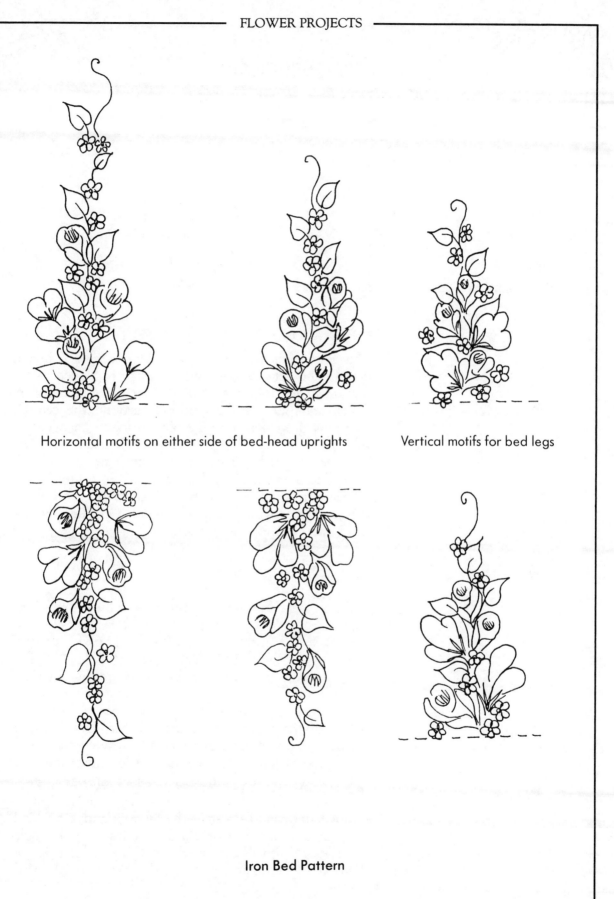

Horizontal motifs on either side of bed-head uprights Vertical motifs for bed legs

Iron Bed Pattern

THE CLOCK

PALETTE

Raw Sienna	Warm White	Titanium White
Turner's Yellow	Gold Oxide	Black
Yellow Light	Green Oxide	Jade

PREPARATION

This pattern is painted on an old pokerwork bread board. The original pokerwork design had been worn off except for the word 'BREAD', so I left that in the design and put corn and poppies around the central chopping area. The poppy colour can be changed to suit your tastes. For convenience I used stick-on numbers although it is better to paint them on.

I sealed the whole board and painted the central circle a cream mix of Raw Sienna and White and then antiqued the edges with Burnt Umber Oil Paint. When this is all dry, apply the pattern.

PROCEDURE

1. **Corn** — Load the round brush with Turner's Yellow and paint in the corn cobs with shape-following strokes. When they are dry, float Gold Oxide on one side (see 'Terms and Techniques of Folk Art' for floated colour, as well as referring to the photograph.) Then load the liner brush with thinned Gold Oxide and paint in the kernels with thin lines according to the pattern. Load the round brush with Green Oxide sideloaded with Jade, and paint the leaves around the corn according to the pattern. Add some fine Teal Green lines at the base of each cob.

2. **Barley** — Mix a touch of Black with Green Oxide. Load the round brush with this mix and a sideload of Cream and paint in the barley leaves with single strokes. With Cream in the brush, sideload lightly in Raw Sienna and paint in the barley heads, also

with single strokes. Add more White to the Cream mix and thin it down with water. With the liner brush, paint in the barley stalks, beards and grain lines.

3. **Poppies** — Base the poppies in White until opaque, then cover with Yellow Light. When this is dry, reload the round brush in Yellow Light, sideloaded with Titanium White. With the White to the outside of the flower, paint the ripple edge of each petal with one stroke, then come back with a series of overlapping comma strokes, pulling them from the white ripple edge down to the centre of the flower. Paint the poppy centre in Raw Sienna, with a float of Brown Earth, then using the liner brush, paint radiating fine lines out from each poppy centre with thinned Raw Sienna.

Allow to dry completely and varnish with several coats of water-based varnish. Apply the numbers and drill the hole for the clock movement shaft.

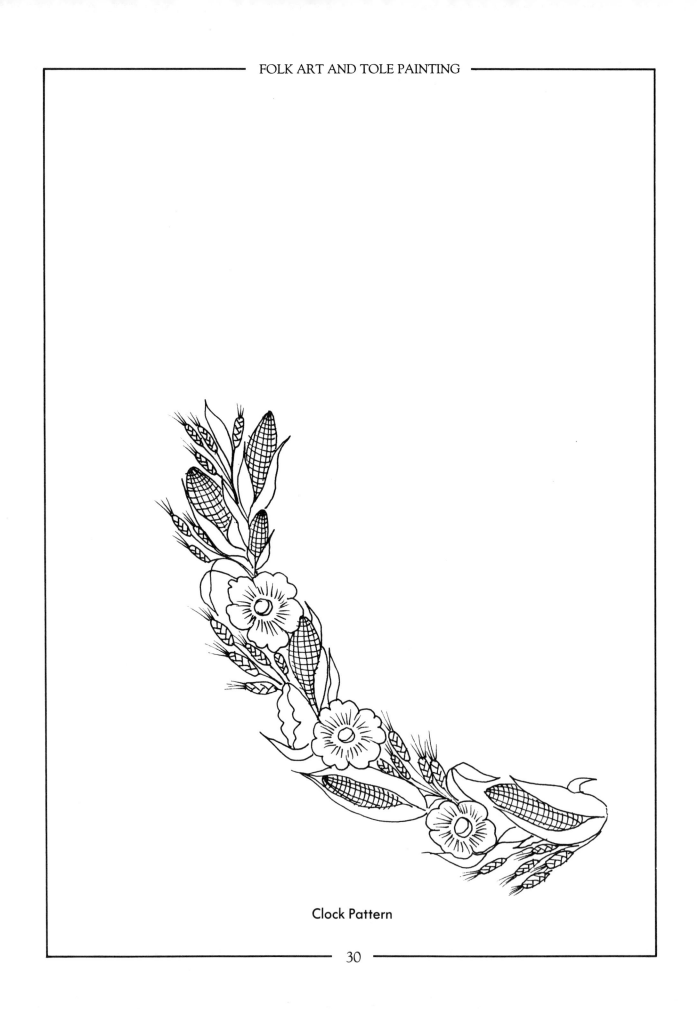

Clock Pattern

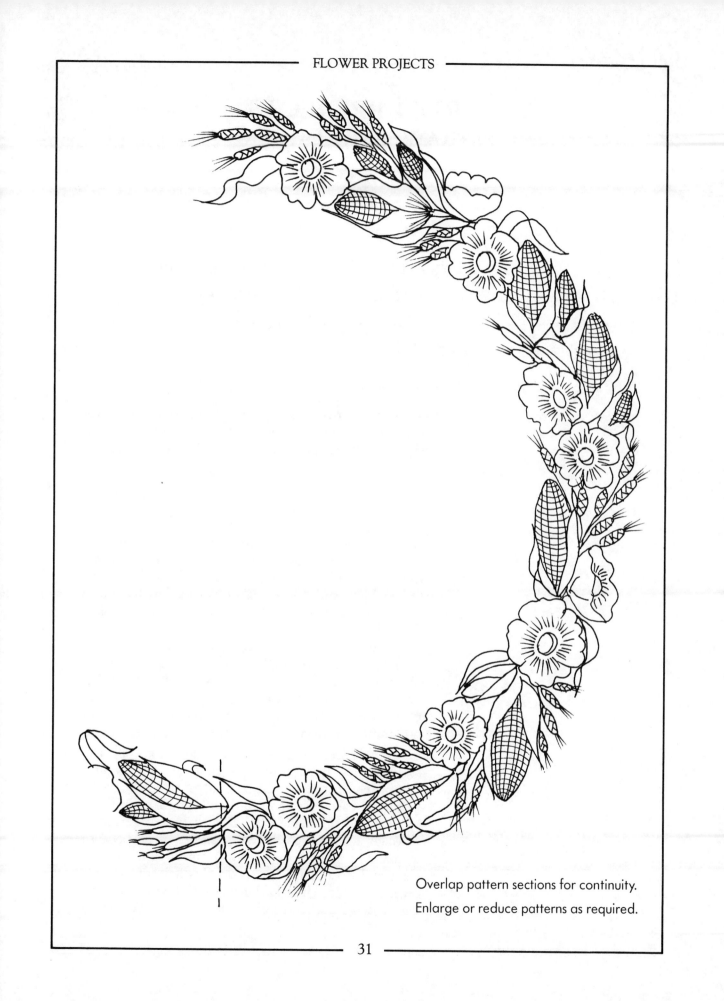

Overlap pattern sections for continuity.

Enlarge or reduce patterns as required.

FRUIT PROJECTS
STRAWBERRY DIPPER

PALETTE

Black	Warm White	Cadmium Scarlet
Turner's Yellow	Yellow Oxide	Teal Green
Burgundy	Olive Green (a mix of Black and Yellow Light — 1:4)	

Jo Sonja Retarder and Antiquing Medium

PREPARATION

Base coat the rust-proof primed metalware with flat black enamel paint — at least two coats. Allow to dry completely and apply the pattern with white transfer paper.

PROCEDURE

1. **Leaves** (These leaves are illustrated step-by-step on the instruction pages in the colour section.) — Load the No. 3 round brush with Olive Green (made by mixing Black and Yellow Light). Sideload with a touch of Yellow Oxide, then paint a series of comma strokes down both sides of each leaf, from the centre vein to the outside edge. The comma strokes must vary to fit the outline of the leaf and make sure you keep the yellow side load on the same side of each stroke. Each time I sideload the Yellow I try to do at least two leaves so some are more heavily striped than others, and the leaves show some variety.

2. **Strawberries** — First of all base coat all the strawberries in White, ignoring the sepals and completely rounding off the tops of each berry. Continue base coating until each berry is completely opaque and no shade of the black base coat shows through. I do this to all yellow and red fruit because it makes the colours so much more intense and vibrant. I do not bother to do this if I am painting on a cream or white background. Allow to dry and base coat all the strawberries in Cadmium Scarlet —

two coats if necessary. Using the wet-on-wet technique (see 'Terms and Techniques of Folk Art'), load a No. 3 brush with Cadmium Scarlet and sideload in Burgundy, then while the previous coat is still wet, paint a shape-following stroke on the lower side of each strawberry, with the Burgundy facing the outer edge. (Try to imagine the highlight on each strawberry coming from the same direction and place the shading on the opposite side.) Blend the Burgundy up into the Cadmium Scarlet base coat. Repeat the process with the wet-on-wet technique, this time with the brush loaded in Cadmium Scarlet and sideloaded in Turner's Yellow, and paint the highlight stroke on the opposite side of the shading on the berry. Blend the Turner's Yellow down into the Cadmium Scarlet. Allow the whole strawberry to dry (use the hairdryer if you wish to keep painting, although be sure the retarder in the base coat is completely dry before you add any more strokes.)

Using the liner brush loaded in Black on the very tip of the brush, paint in the strawberry seeds. These should be pointing downwards and appear to be randomly placed. I try to put them closer together as they get to the point of the berry. Each of the little black seeds on the light side of the berry has a highlight in white and the seeds on the shaded side have a shadow of Burgundy. Those seeds in the central area (halfway between highlight and shadow) have both white and Burgundy on them. This may seem tedious when you look at the size of the strokes, but it really adds to the realistic effect of the strawberries.

Go back to the Olive Green of the leaves and with the round brush and a sideloading of Teal Green, paint the strawberry crowns or sepals with flourishing comma strokes, with reference to the photograph. If necessary replace the pattern and reapply with light-coloured transfer paper.

3. **Stems** — Load the liner brush with watered-down Teal Green and a touch of Warm White, and paint in the stems and veins on the whole design.

4. **Flowers** — Finally, with the round brush loaded with Warm White, paint the petals of the strawberry flowers with two shortened comma strokes, each joined together to make one petal. When the petals are dry, dot the yellow centres of the flowers.

Allow to dry and cure, then varnish with several coats of satin water-based varnish.

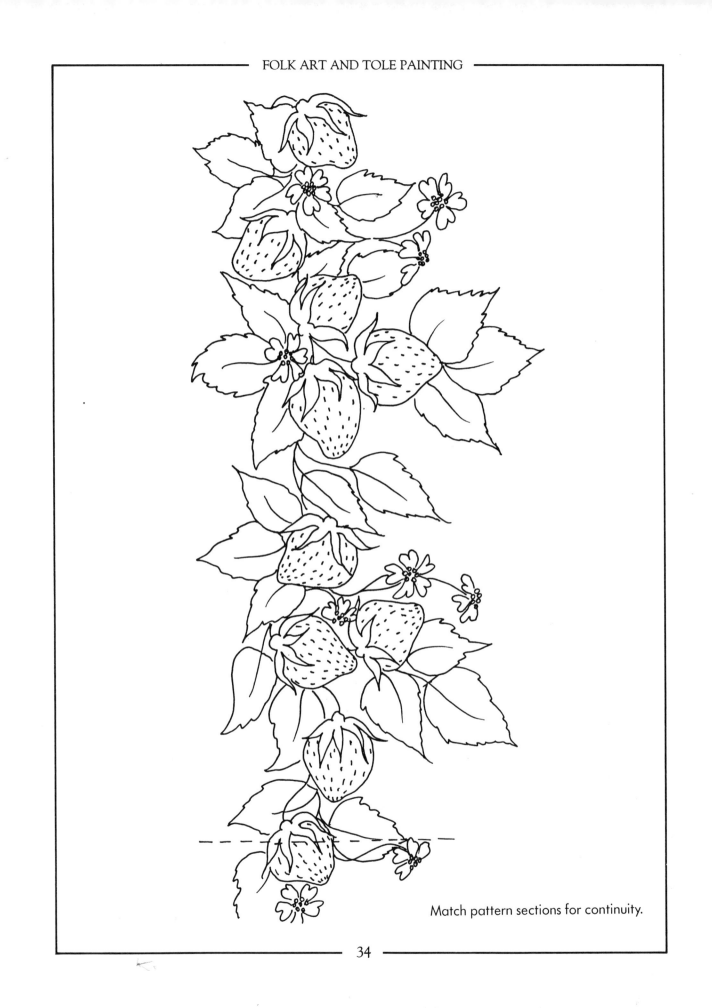

Match pattern sections for continuity.

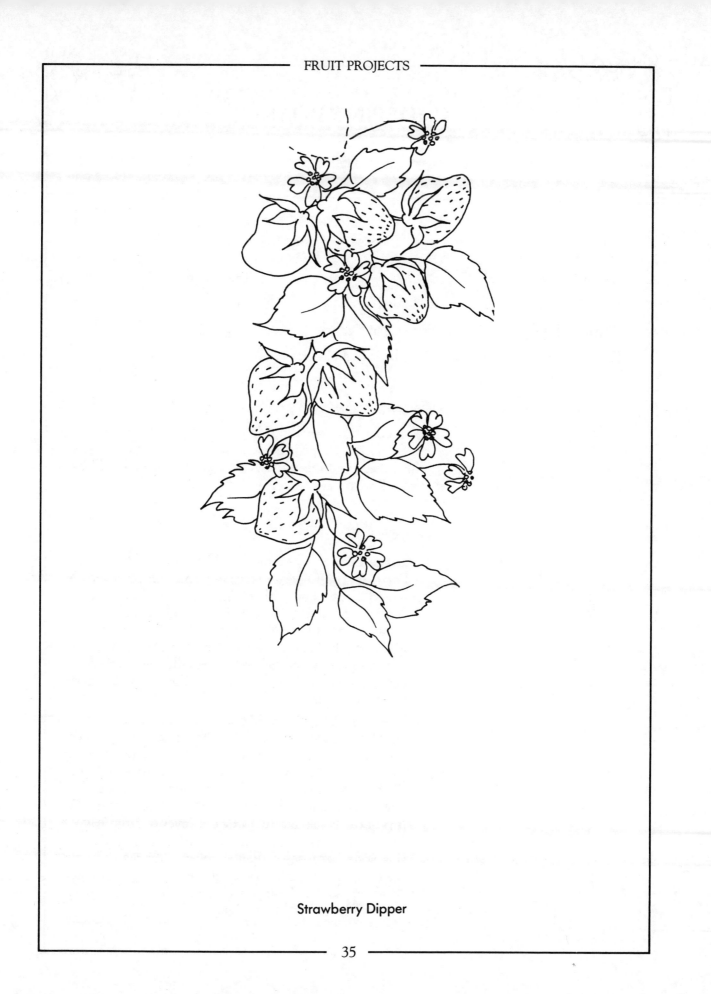

Strawberry Dipper

CHOPPING BOARD

PALETTE

Green Oxide	Black	Raw Sienna
Brown Earth	Red Earth	Turner's Yellow
Warm White	Norwegian Orange	Burgundy

Olive Green (a mix of Black and Yellow Light — 1:4)

PREPARATION

Base coat the board in Olive Green mixed with a little Jo Sonja All Purpose Sealer. Allow to dry and transfer the foliage outline only. Base coat this in solid Black and allow to dry.

PROCEDURE

1. **Large Leaves** — Mix a dark Olive by adding Brown Earth to the Olive Green base coat. Using a No. 5 round brush and either single fat or double large comma strokes, paint a series of large simple leaves around the perimeter of the black background. Ignoring the black pattern underneath, place the leaves in a random fashion, but with their points all heading basically to the outside edge. Outline these with Raw Sienna.

2. **Medium Leaves** — Mix a touch of Green Oxide and Raw Sienna with White for a soft grey green and paint in the medium-sized leaves. I usually do these as ivy leaves by overlapping the rounded end of three comma strokes. The medium leaves are also placed randomly around the outside edge over the top of the black and the previous layer of large leaves. Jo Sonja Artist's Colours are particularly good for this style because of their excellent coverage. If you are using other paints you might need to do two coats so as not to see the layers underneath. Outline these medium leaves in Green Oxide.

3. **Small Leaves** — Mix a little Red Earth with Warm White and using a No. 2 round or a liner brush, dab in a series of little leaves on stems with the same arrangement as the previous layers of leaves. Outline these leaves with Red Earth. Now centre and transfer the fruit pattern onto the foliage.

4. **Cumquats** — Base coat the cumquats in Norwegian Orange. Highlight with Yellow Oxide and shade with Red Earth. With Brown Earth in the liner brush, paint a stem from each cumquat to the nearest citrus fruit.

5. **Limes** — Mix a little White and Turner's Yellow with Green Oxide and base coat in the limes with this. Shade with Burnt Umber and highlight with Yellow Light. Dry brush a final highlight of White on each lime.

6. **Orange** — Base in the orange with Red Earth. Highlight with Norwegian Orange and shade with Burgundy. Dry brush a White highlight in the same direction as the other fruit.

7. **Lemons** — Base with Turner's Yellow. Shade with Raw Sienna and highlight with Yellow Light. Dry brush in White highlight. Paint the edges of the board with Red Earth. Antique the piece according to the steps in the 'Terms and techniques of Folk Art'.

Allow to dry completely, cure, and varnish with several coats of satin water-based varnish.

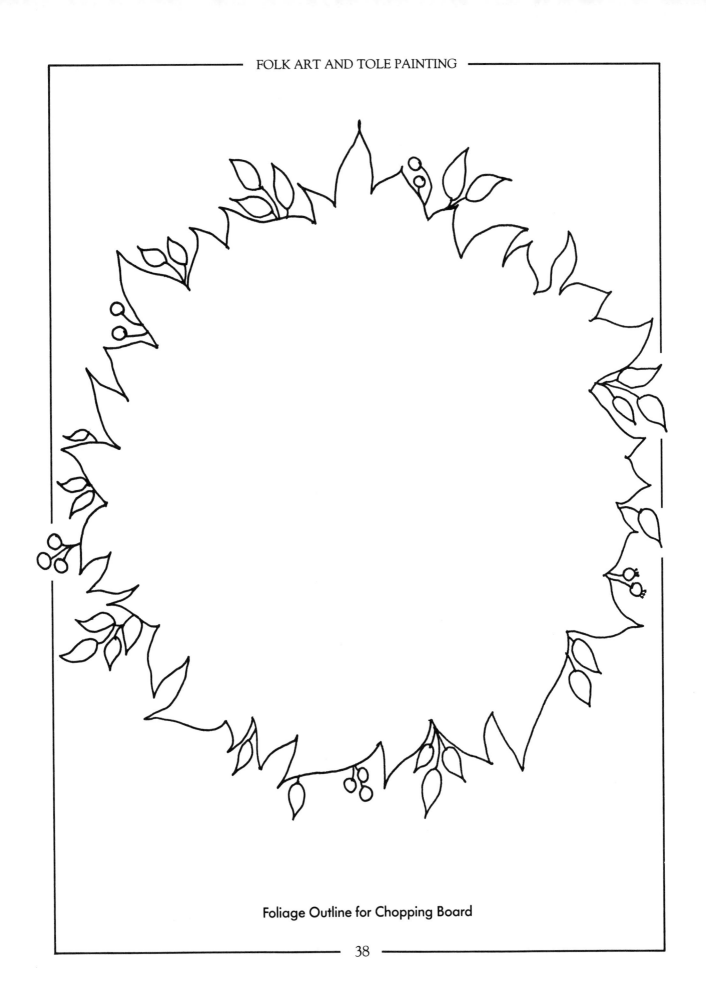

Foliage Outline for Chopping Board

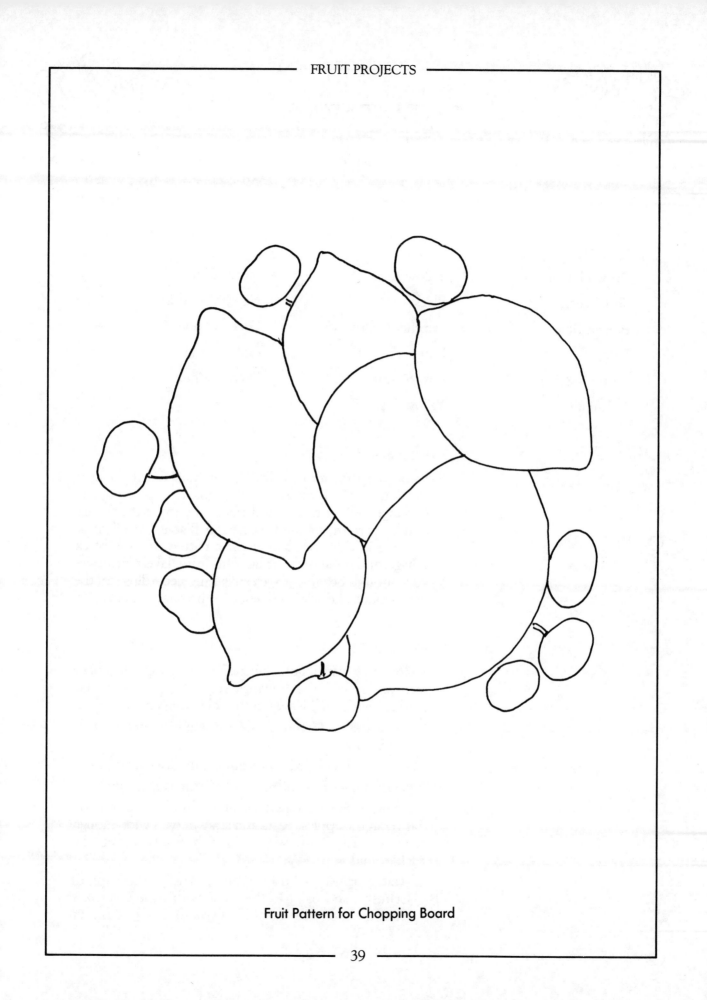

Fruit Pattern for Chopping Board

FRUIT STOOL

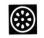

PALETTE

Brown Earth	Yellow Light	Storm Blue
Teal Green	Black	Napthol Red Light
French Blue	Napthol Crimson	Green Oxide
Jade	Burgundy	Gold Oxide
Turner's Yellow	Raw Sienna	Warm White
Vermilion	Yellow Oxide	

PREPARATION

Base coat the stool in Teal Green mixed with a little Jo Sonja All Purpose Sealer, ensuring a complete coverage. Allow to dry and trace and apply the foliage outline pattern, basing this area in Black. For all these patterns in this style I only use a pattern for the black foliage outline and the fruit. The three layers of leaves you should be able to freehand in according to the instructions and with reference to the photographs.

PROCEDURE

Follow the instructions given for the chopping board (see pages 36–7), followings steps 1-3 for the large, medium and small leaves in the following colours.

Large Leaves — Green Oxide, outlined in Green Oxide and Jade mix.

Medium Leaves — Jade with outline in Gold Oxide.

Little Leaves — Raw Sienna and Warm White mix.

Transfer the fruit pattern onto this layered foliage. Base coat the apples, pears and strawberries with enough coats of Titanium White to completely cover the background.

1. **Red Apples** — Load a round brush with Napthol Crimson and paint in the apple with large C-strokes from the top to the bottom. If you follow the contour

of the apples with your paint strokes this will help create the three dimensional shape. Shade the lower half of the red apples with Burgundy and highlight the top with Napthol Red Light using the wet-on-wet technique. When highlighting apples I use a series of narrow C-strokes over the roundest shoulder of the apple, which imitates the stripes that apples often have. When these highlights are dry, drybrush a few strokes of Vermilion on the rounded area. Finally, load the brush with Napthol Crimson, sideloaded in Burgundy, and with the Burgundy on the lower side place a small C-stroke in the neck of the apple. Load the liner brush with Brown Earth and paint stalk.

2. **Green Apple** — The green apple is painted the same way as the red with the following colours: Base — Green Oxide and Yellow Light mix. Shading — Green Oxide. Highlight — Jade and Yellow Light.

3. **Pears** — Base the pears in Turner's Yellow, shade with Raw Sienna and highlight with Yellow Light, still using the wet-on-wet technique.

4. **Peaches** — Mix Warm White with a little Red Earth and a touch of Raw Sienna until you have a peachy pink. Base in peaches with this, then with retarder in the brush, sideload in Yellow Oxide and highlight the crease and the side of the peach next to the crease. This highlight can be floated on after the base coat has dried if you do not wish to use the wet-on-wet technique. Shade the lower side of the peaches with Red Earth.

5. **Strawberries** — Base coat the white painted strawberries in Napthol Red Light. Shade each strawberry with Burgundy using either floated colour with a flat brush or wet-on-wet, blending on the lower side of each strawberry. You have to decide which side this is going to be — the important thing is to be consistent and to shade and highlight on the same side of each strawberry. Highlight the berries with Turner's Yellow, then load the liner brush with some thinned Black and tip in the seeds on each strawberry with the tiniest comma strokes you can manage. Highlight each seed on the same side with a tiny dot or stroke of White. Finally, paint in the strawberry crowns in Teal Green with the liner brush.

6. **Grapes** — Paint one third of all the grapes in French Blue. Shade each painted grape with Storm Blue and highlight them with a mix of French Blue and White. Allow these to dry. To this highlight mix add a touch

of Burgundy to make a blue-mauve and paint another third of the grapes with this colour. Paint each grape as a complete circle, overlaying the complete circles of the first third of grapes. Shade this second third with straight French Blue and then highlight with the base mix to which more White has been added. The remaining third of grapes are painted (also in complete circles) over the first two thirds in a Burgundy pink, mixed from Burgundy, White and a touch of French Blue. Shade with straight Burgundy and highlight with a drybrush of White.

7. **Flowers** — Load the liner brush heavily with Warm White and paint in the flowers with two comma strokes for each petal. Add Turner's Yellow dots in the centre of each flower.

Paint the edges of the stool legs in a contrasting colour, cure and antique the piece according to the steps in the 'Terms and Techniques of Folk Art'. Allow to dry completely and varnish with several coats of satin water-based varnish.

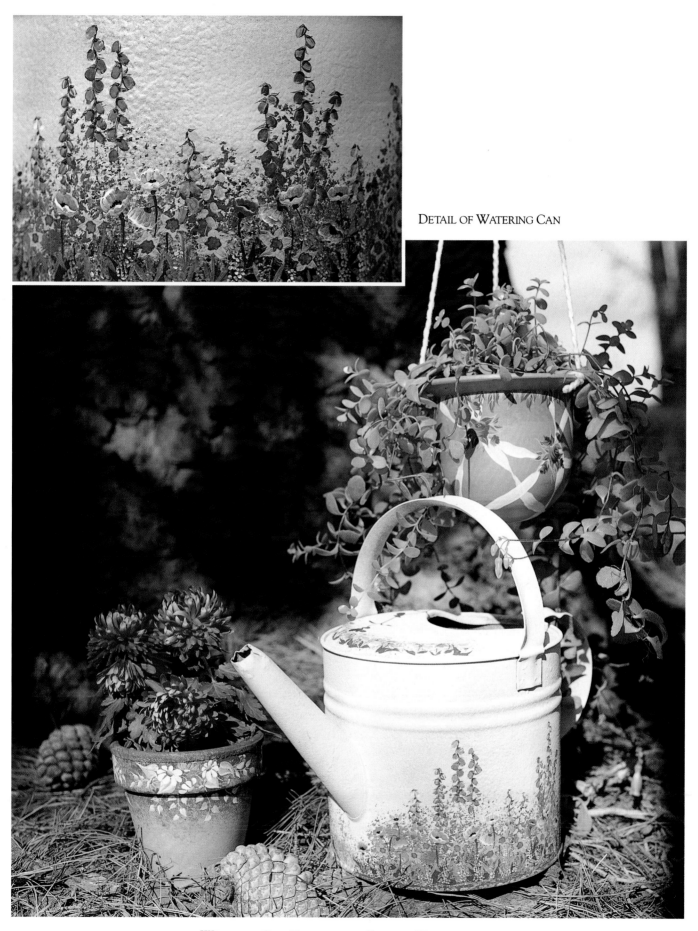

DETAIL OF WATERING CAN

WATERING CAN, TERRACOTTA POT AND HANGING POT

BEDSIDE CABINET

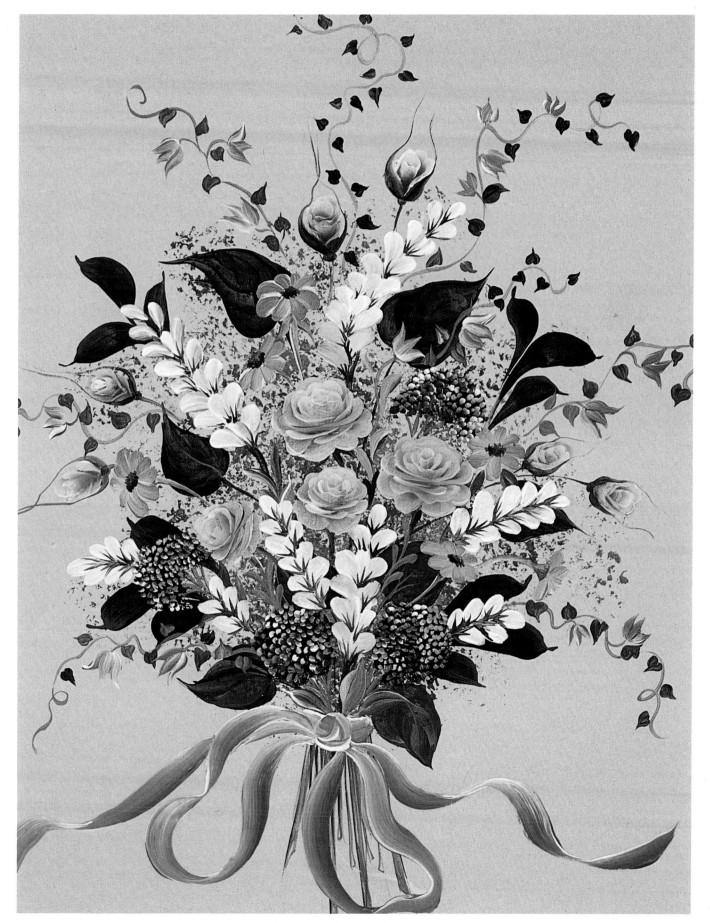

DETAIL OF BEDSIDE CABINET

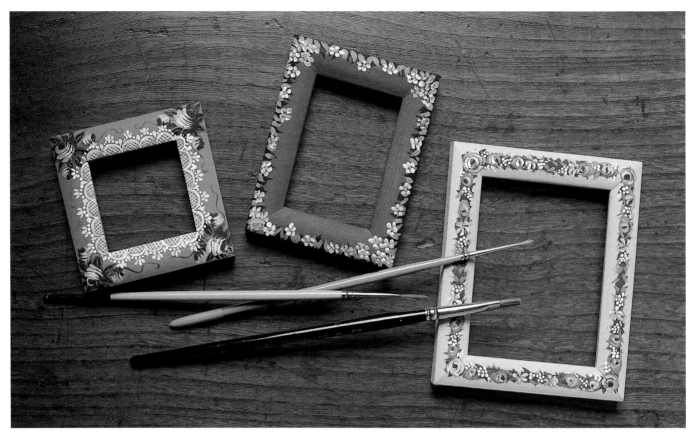

FRAMES (FROM LEFT TO RIGHT): SQUARE FRAME
RECTANGULAR FRAME AND LARGE RECTANGULAR FRAME,

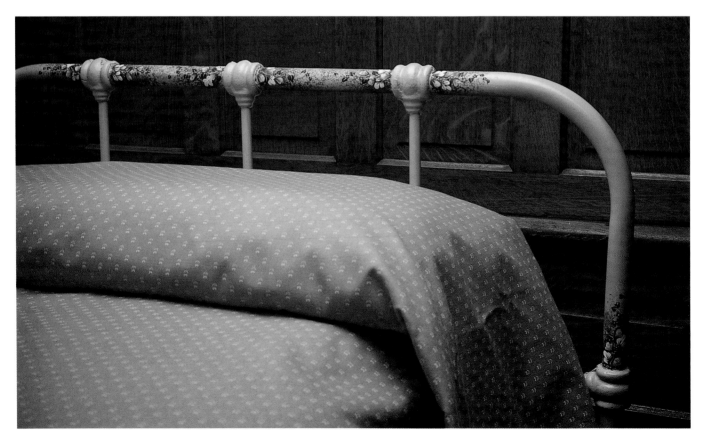

THE BED

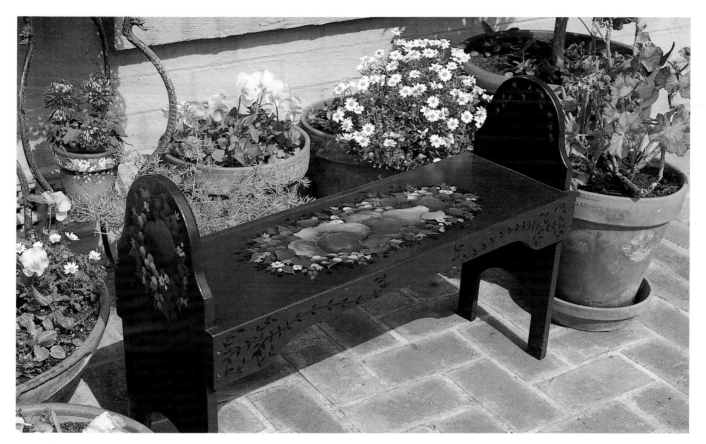

LARGE FRUIT BENCH

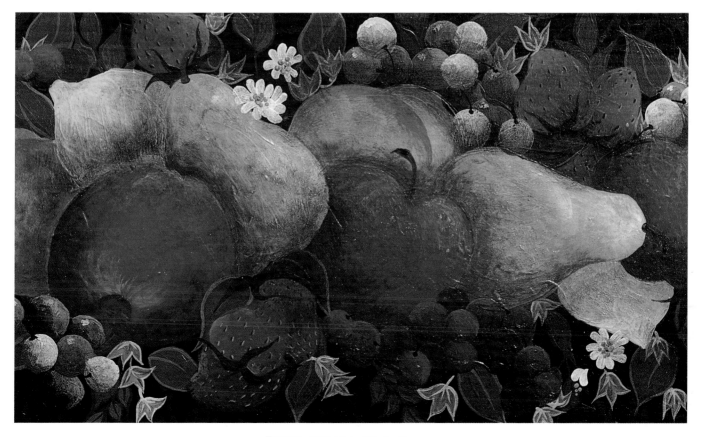

DETAIL OF LARGE FRUIT BENCH

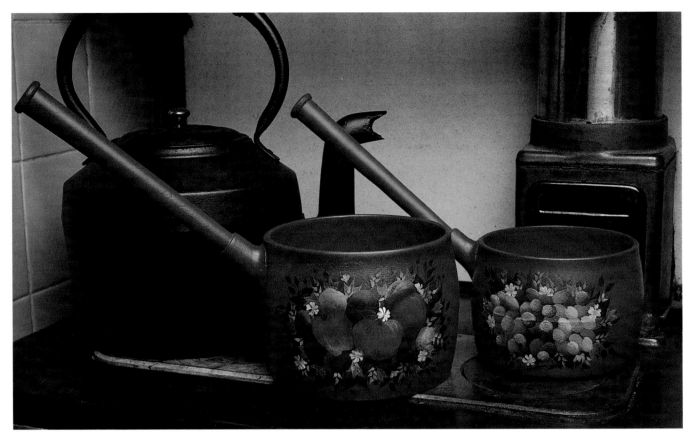

Plum Saucepan (left) and Grape Saucepan (right)

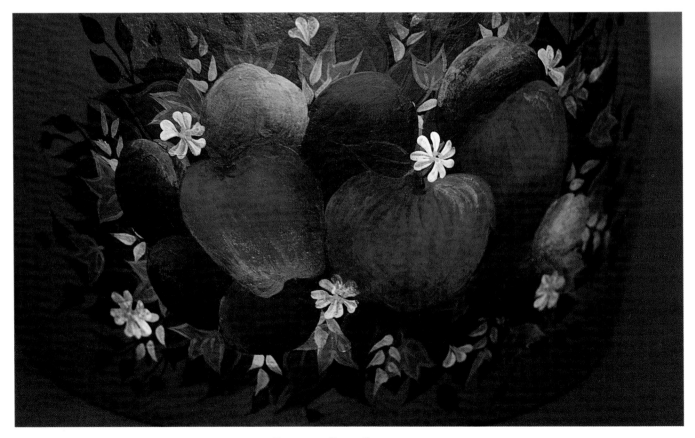

Detail of Plum Saucepan

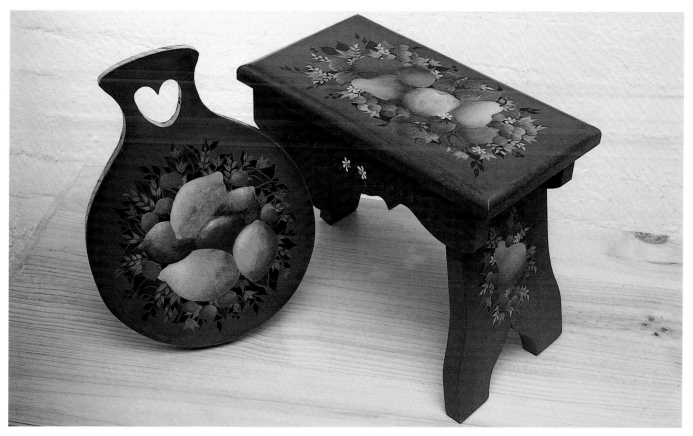

CHOPPING BOARD AND STOOL

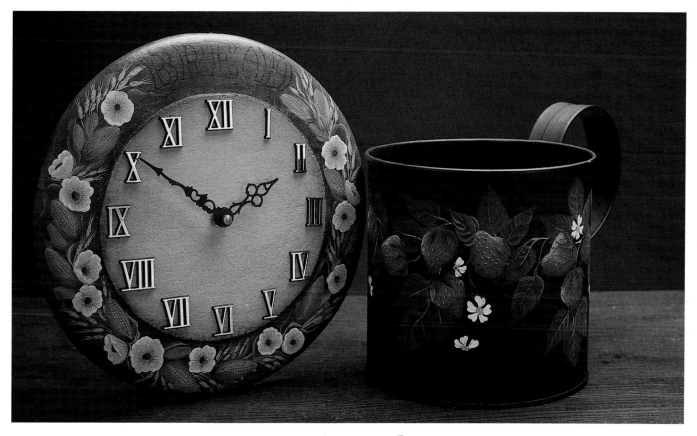

CLOCK AND STRAWBERRY DIPPER

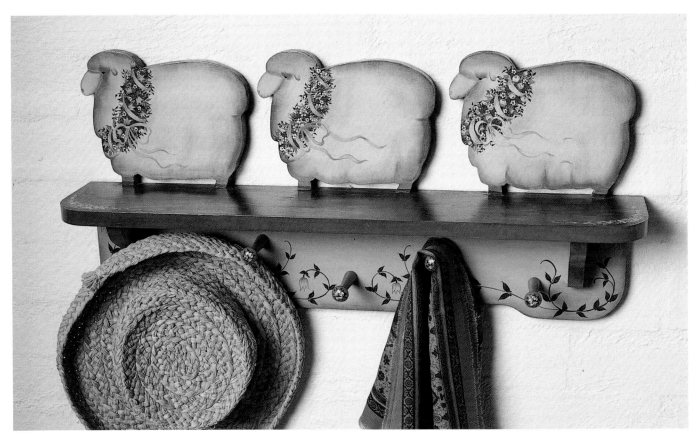

SHEEP SHELF

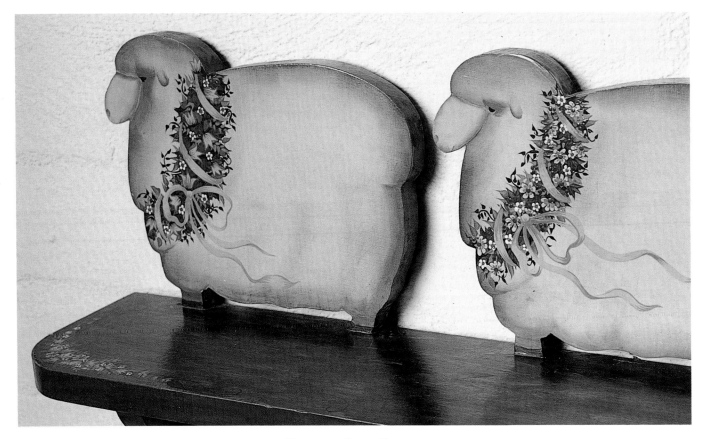

DETAIL OF SHEEP SHELF

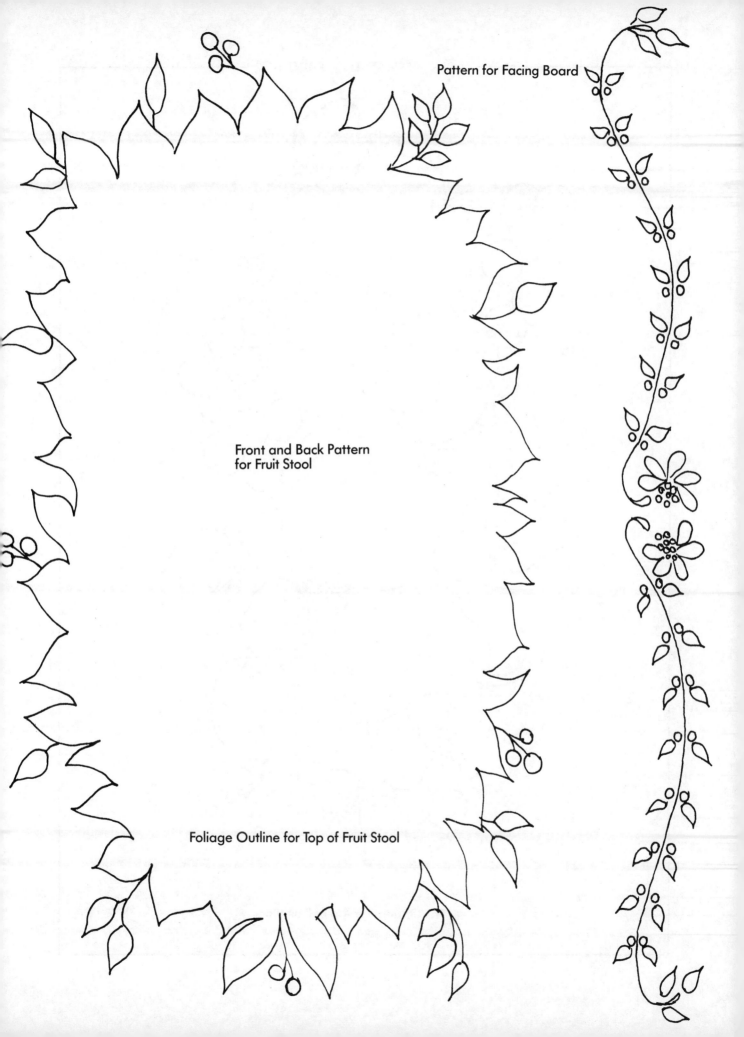

Pattern for Facing Board

Front and Back Pattern
for Fruit Stool

Foliage Outline for Top of Fruit Stool

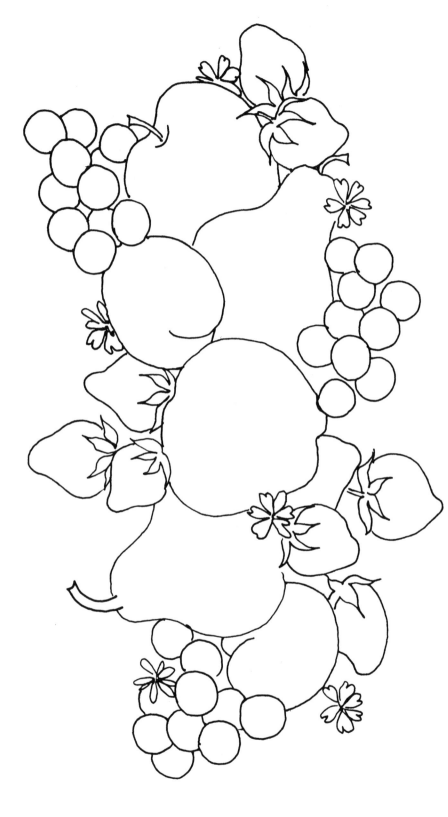

Fruit Pattern for Top of Fruit Stool

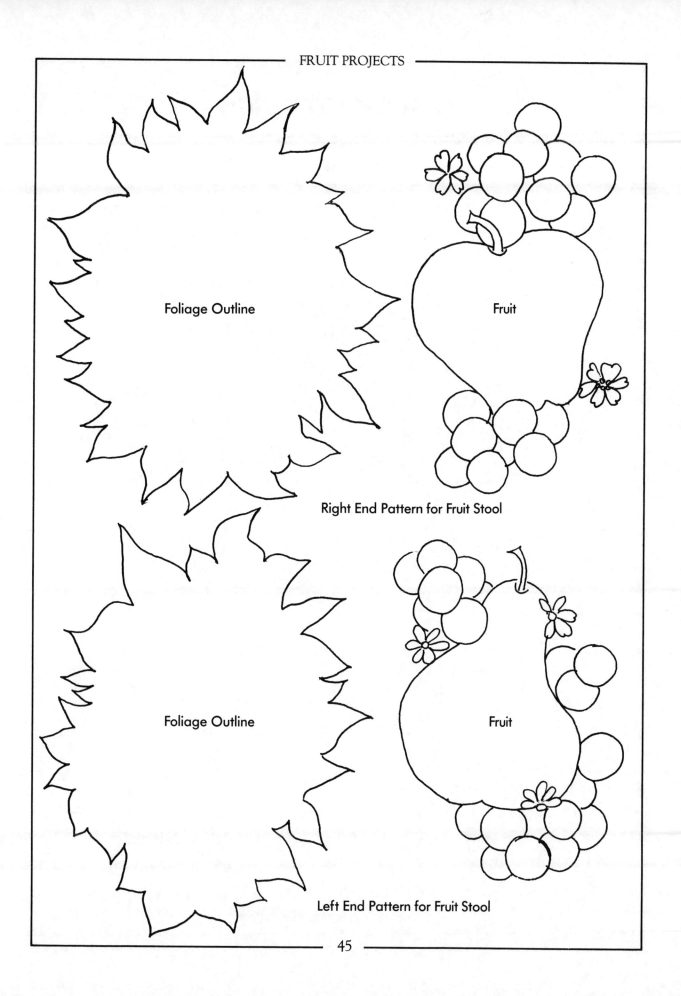

Foliage Outline

Fruit

Right End Pattern for Fruit Stool

Foliage Outline

Fruit

Left End Pattern for Fruit Stool

LARGE FRUIT BENCH

Detailed instructions have not been included for this piece because it is simply a larger version of the Fruit Stool, using all the same colours and the same methods, but on a larger scale. All the patterns for this piece have been included.

Overlap pattern sections for continuity.

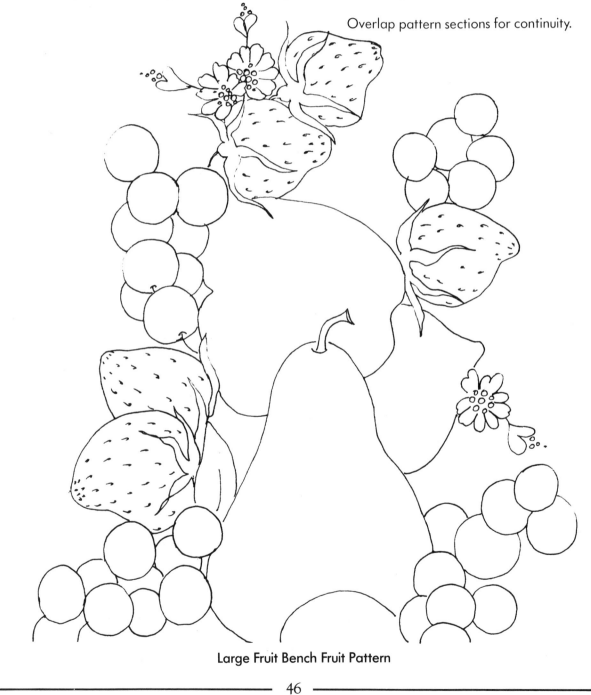

Large Fruit Bench Fruit Pattern

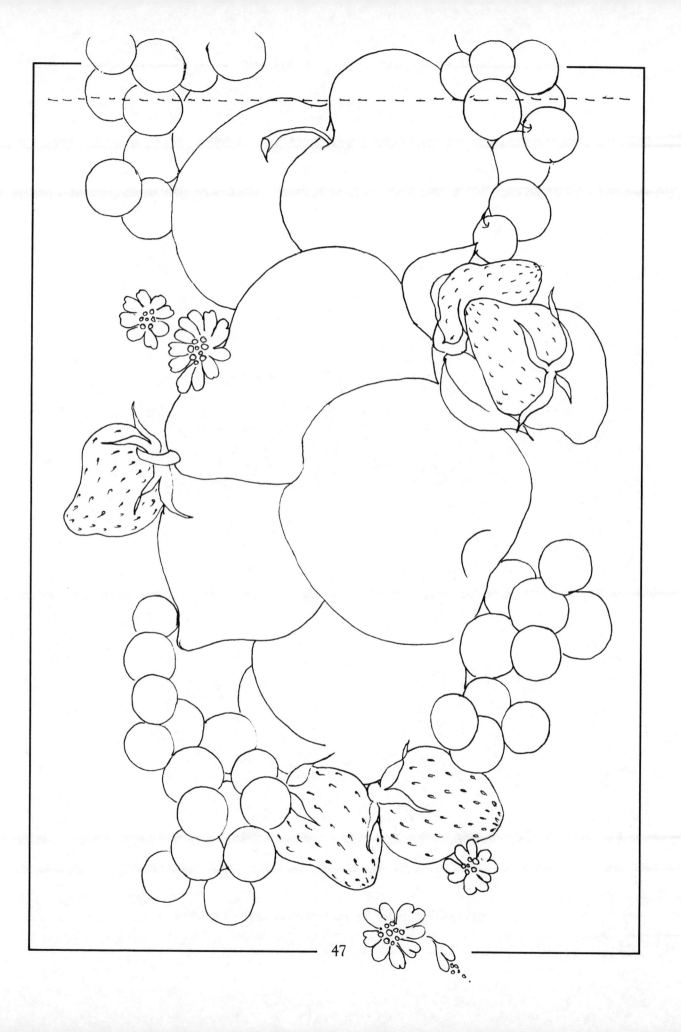

47

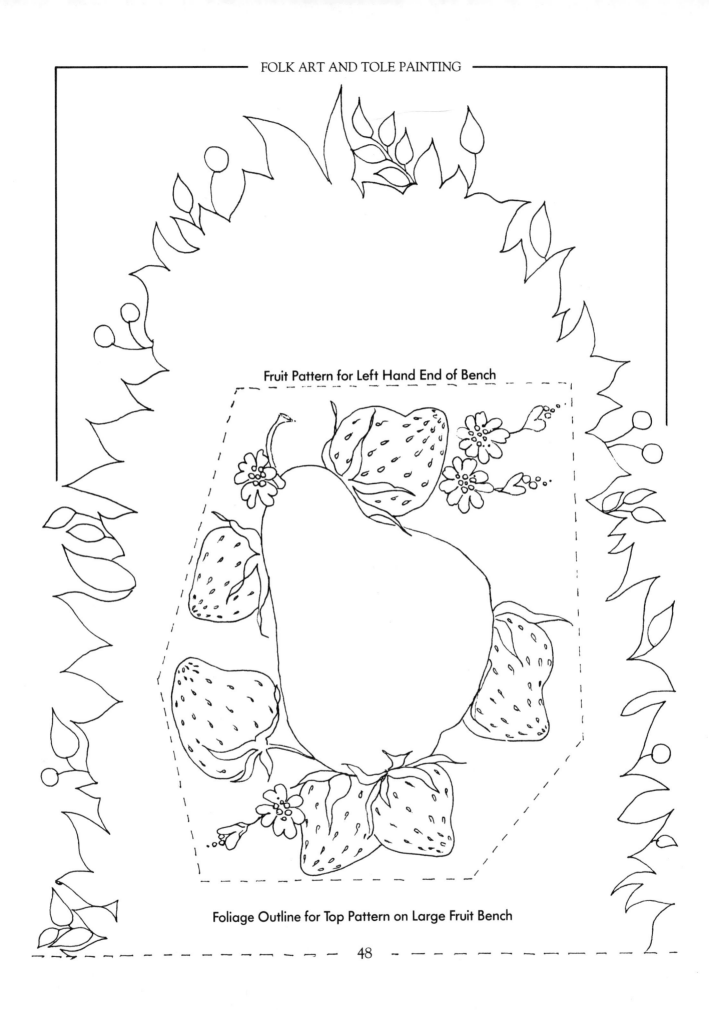

Fruit Pattern for Left Hand End of Bench

Foliage Outline for Top Pattern on Large Fruit Bench

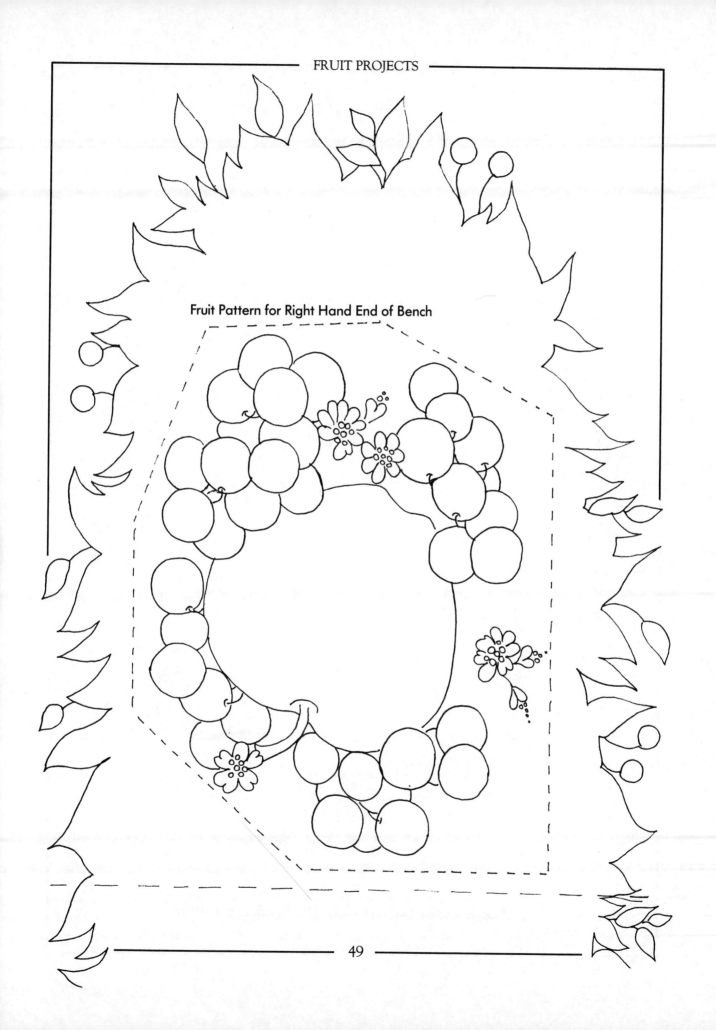

Fruit Pattern for Right Hand End of Bench

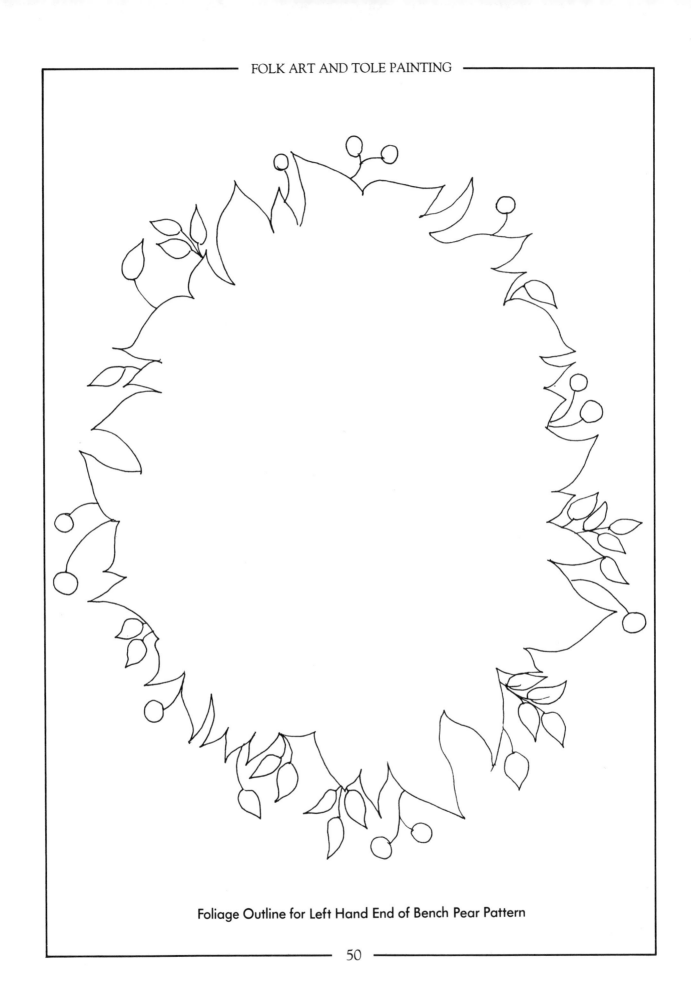

Foliage Outline for Left Hand End of Bench Pear Pattern

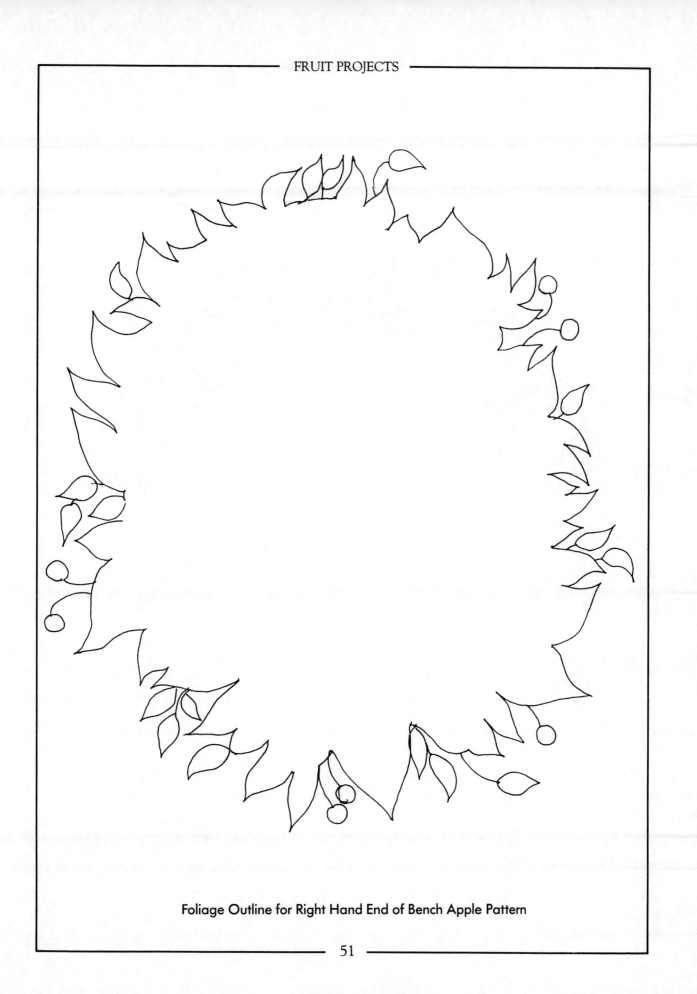

Foliage Outline for Right Hand End of Bench Apple Pattern

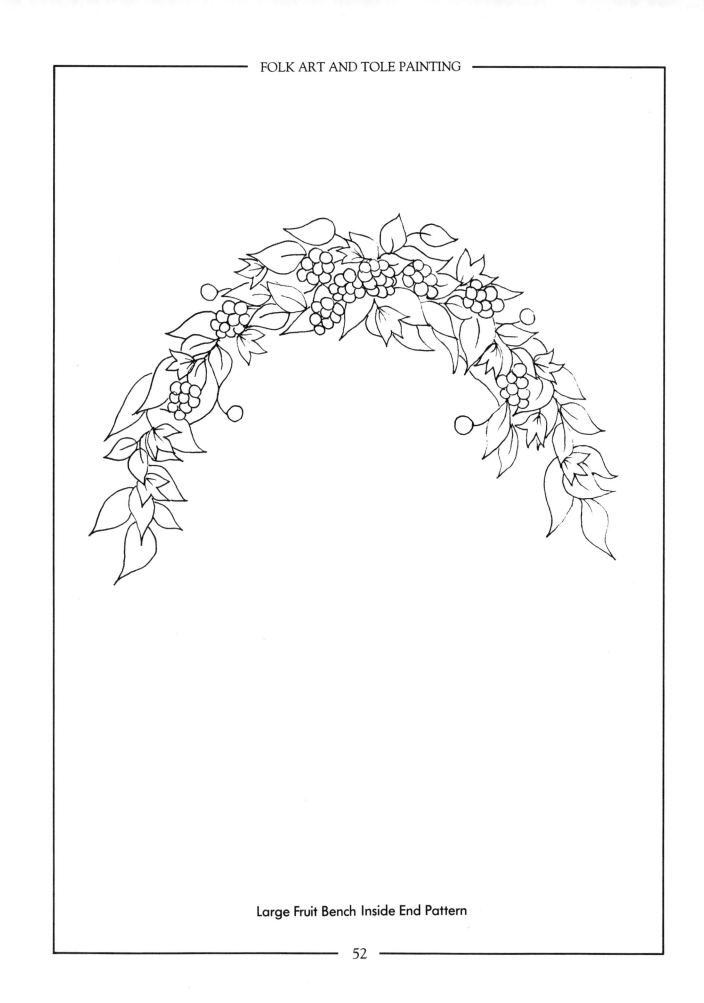

Large Fruit Bench Inside End Pattern

GRAPE SAUCEPAN

PALETTE

Black	Burgundy	Yellow Oxide
Moss Green	Red Earth	Green Oxide
Titanium White	Napthol Red Light	Yellow Light
Teal Green	French Blue	Turner's Yellow
Storm Blue		

PREPARATION

Base coat the saucepan with Red Iron Oxide Metal Primer. When dry, trace and apply the foliage outline pattern onto one side of the saucepan and base in the area with Black. Allow to dry.

PROCEDURE

1. **Large Leaves** — This is the first of three layers of foliage, which I always freehand. Using a No. 3 round brush, paint a series of large simple leaves in Teal Green around the outer edge of the black foliage background. I usually paint these with large single or double comma strokes overlapped. These should all be basically the same size but varied in their direction. The thing to avoid is having the leaves all lined up and equally spaced so they look like a row of rabbits ears. This is a very easy trap to fall into, because once you get into the rhythm of painting the leaves they all want to look the same! Outline these large leaves in Green Oxide.

2. **Medium Leaves** — Paint the medium leaves in Green Oxide. I usually make them ivy leaves, using three comma strokes with their rounded ends overlapping. Outline these leaves with a light green mix of Green Oxide and Yellow Oxide.

3. **Small Leaves** — Paint little frondettes or sprays of little leaves, again randomly around the outer edge

of the foliage outline and over the top of the two previous layers of leaves. These are painted in Moss Green. You can outline these and put a stem in them if you wish — it depends on how much time and energy you have.

4. **Grapes** — These are painted the same way as the grapes on the Fruit Stool (see pages 41–42) except that I have divided them into red, blue and green grapes. Each colour is divided into three shades of base colour with associated light and dark shading and highlighting. Painting grapes can be considered tedious and time consuming but the reward is that they are the most three dimensional fruit to paint and, I think, look the most delicious!

Red Grapes — Base the first third of the grapes in a mix of Burgundy and White with a touch of French Blue. Shade in straight Burgundy and highlight with the base colour with White added. The second third of the red grapes are based in a lighter pink, made by adding more White to original base mix, and are shaded with the original base mix and highlighted with the second base mix plus more White. As you will see each time you paint another layer of grapes you go up a value in all three colours of shade, base and highlight. The last third of the red grapes should be the palest pink, made by adding more White to the base colour, with a darker shading pink and a straight White highlight.

Blue Grapes — Using the same divisions and colour arrangements as the previous grapes apply the following colours. First third: base mix of French Blue with a touch of Burgundy, shade with Storm Blue, highlight with straight French Blue. Second third: base in straight French Blue, shade with Storm Blue and French Blue mix, highlight with French Blue mixed with a little White. Last third: base in French Blue and White mix, shade in straight French Blue and highlight with White.

Green Grapes — First third: base in a mix of Green Oxide and Yellow Light, add a touch of Black to this base mix for the shade colour and highlight with Yellow Oxide. Second third: add a touch of Yellow Oxide to the first base mix and paint in second layer, shade these with the base mix with a touch of Storm Blue added and highlight with Moss Green. Final third: base in Moss Green plus White, shade in Moss Green and highlight with base mix plus White.

5. **Flowers** — Load the liner brush heavily with Titanium White and paint in the flowers with two joined comma strokes for each petal. Dot in Yellow Oxide centres.

Allow to dry completely, cure, and antique according to the steps in 'Terms and Techniques of Folk Art'. Allow to dry and varnish with several coats of satin water-based varnish.

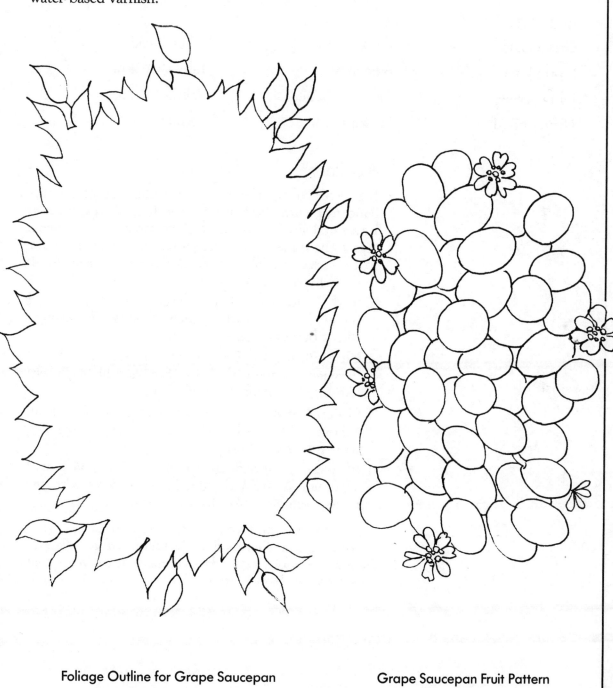

Foliage Outline for Grape Saucepan Grape Saucepan Fruit Pattern

THE PLUM SAUCEPAN

PALLETTE

Green Oxide

Storm Blue

Ultramarine

Napthol Red Light

Black

Burgundy

Titanium White

Brown Earth

Yellow Oxide

Turner's Yellow

Napthol Crimson

Vermilion

PROCEDURE

Base coat using the same procedure as the Grape Saucepan, with the Black foliage, large leaves, medium leaves and small leaves having the same colour scheme. Apply the apples and plums pattern and paint according to the directions for the Fruit Stool (see pages 40–1) in the following colours.

1. **Red Plums** — Base in Burgundy, shade with Burgundy mixed with a touch of Black and highlight with a Burgundy plus White mix.

2. **Blue Plums** — Base in Storm Blue mixed with Burgundy, shade with Storm Blue and highlight with Ultramarine and a touch of White.

3. **Green Plums** — Base in a mix of Green Oxide and Yellow Oxide, shade with Green Oxide and highlight with Turner's Yellow.

4. **Flowers** — Load the liner brush heavily with Titanium White and paint in the flowers with two joined comma strokes for each petal.

Allow to dry completely, cure, and antique according to the steps in 'Terms and Techniques for Folk Art'. When the antiquing is dry, varnish with several coats of satin water-based varnish.

Foliage Outline for Plum Saucepan.

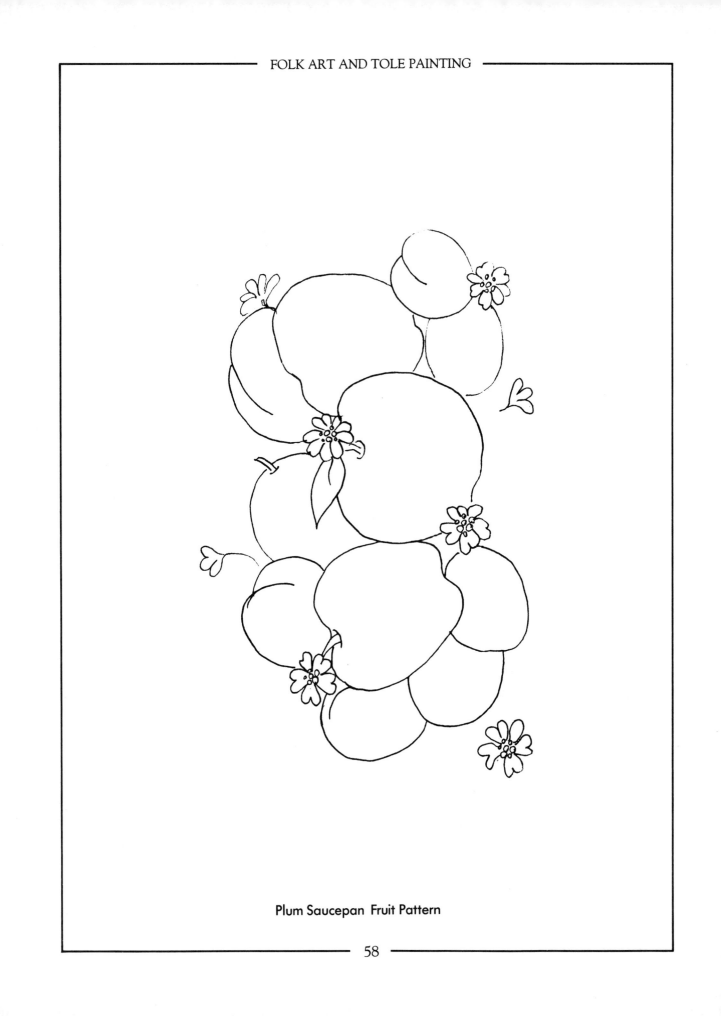

Plum Saucepan Fruit Pattern

THE SHEEP SHELF

PALETTE

Provincial Beige	Fawn	Warm White
Turner's Yellow	Yellow Oxide	Brown Earth
Plum Pink	French Blue	Black
Green Oxide	Burgundy	Indian Red Oxide
Teal Green	Smoked Pearl	Jo Sonja Clear Glaze Medium
Raw Sienna	Olive Green (a mix of Black and Yellow Light — 0.5:3)	

PREPARATION

Base coat the entire shelf in a mix of Provincial Beige, Fawn and White. To base the top of the horizontal shelf add some Jo Sonja Clear Glaze Medium to Brown Earth and paint a textured coat of dark brown. I used a 1″ flat brush and painted wriggly twisted strokes all over. Base coat the edges in straight Provincial Beige. Allow to dry completely and apply the pattern.

Base coat the sheep in a beige mix of Smoked Pearl with a touch of Provincial Beige.

PROCEDURE

1. **Sheep** — With a large flat brush, float Provincial Beige right around the outer edge of each sheep. Place an extra heavy float over the eye and around the edge of the ear. Base the face with a yellow beige mix of White with a touch of Yellow Oxide and float the edges of the face, the nose and the mouth with Raw Sienna. Paint the ankles in Fawn and the hooves in Brown Earth.

2. **Wreath** — Although I have provided the pattern for each wreath I feel it is easier to freehand these patterns in layers, much the same as the frames, with reference to the photograph. Rough brush (see 'Terms and Techniques of Folk Art') a Teal Green wreath around each sheep's neck. With a round brush, stroke a generous scattering of comma-stroke leaves in

Green Oxide. When these are dry, change to Olive Green and paint a series of ivy leaves randomly scattered over the previous leaf layer by painting three short commas with their fat ends overlapped. Outline these leaves in Brown Earth. Add some Turner's Yellow to Green Oxide to make a light bright Green and, with the liner brush, dab in some frondettes over any space there might be left. Add some little fine line stems curling out from the wreath edges in Brown Earth, with small Teal Green comma leaves attached to them. All the wreaths are the same up to this point. The following instructions will only be for the ribbons and flowers.

Wreath A — Blue Ribbon — Mix a Pale Blue with French Blue and Warm White and, using a No. 3 round brush, paint the ribbon bow and tails in this colour. Change to the liner brush and mix a slightly darker blue from the same colours. Painting very fine lines with this colour, shade the narrow areas of the ribbon. Refer to the photograph.

Flowers — Yellow Roses — Using the creamy yellow you mixed for the muzzle of the sheep, paint in a series of circles (for the roses) and ovals (for the buds) over the wreath. Place a tiny oval, for the throat of the rose, in Raw Sienna on each of the yellow roses and rosebuds and a float of the same colour with a C-stroke on the bases of the circles and ovals with a small flat brush. Load the small flat brush with Warm White and float a couple of frilly strokes on each rose around the throat.

Add a smattering of White dot daisies with Raw Sienna centres, using the stylus, a skewer, a pencil or your brush handle to dip the point in the White paint and then make a dot with this point on the painting surface. Do this five times in a circle, then add a Raw Sienna dot for the centre. Also put in triple berry dots in Burgundy.

Wreath B — Pink Ribbon — Mix a soft pink with a little Plum Pink, a touch of Raw Sienna and a lot of Warm White and paint in the ribbon using the same steps as Wreath A. Add a little more Plum Pink for the darker shade.

Flowers — Blue Daisies — Use the same French Blue and White mix of Wreath A ribbon and paint mini-daisies in the pale blue mix. These are painted with a circle of small curved comma strokes. Then on top of these paint an inner circle of even smaller

comma strokes in the darker shading blue mix, with a dot of straight French Blue for the centres. Refer to the photograph for placement. Continue with dot daisies and berries as in Wreath A.

Wreath C — Yellow Ribbon — Use the same creamy yellow mix of White and Yellow Oxide as you used for the sheep face and the Wreath A roses. To mix the darker shading yellow add a little Raw Sienna to the base mix and do the fine-line shading according to the pattern.

Flowers — Pink Tulips — Use the same pink mixed for the Wreath B ribbon to stroke in a triplet of comma strokes with their round ends overlapping to form a tulip shape. With the liner brush, outline each of these in the darker pink and draw a few short lines up from the base of each flower. Paint fine lines in Teal Green to form each little crown or calyx. Add the same berries and dot daisies on this wreath.

The swag of flowers on the top of the shelf are all repeats of the wreath flowers, as are the little flower clusters on each peg. The sprays on the lower back of the shelf are leaves of Teal Green, outlined in Brown Earth, berries in Indian Red Oxide and tulips in the previous mix of Warm White, Plum Pink and Raw Sienna. When all the painting is dry and cured, varnish with several coats of satin water-based varnish.

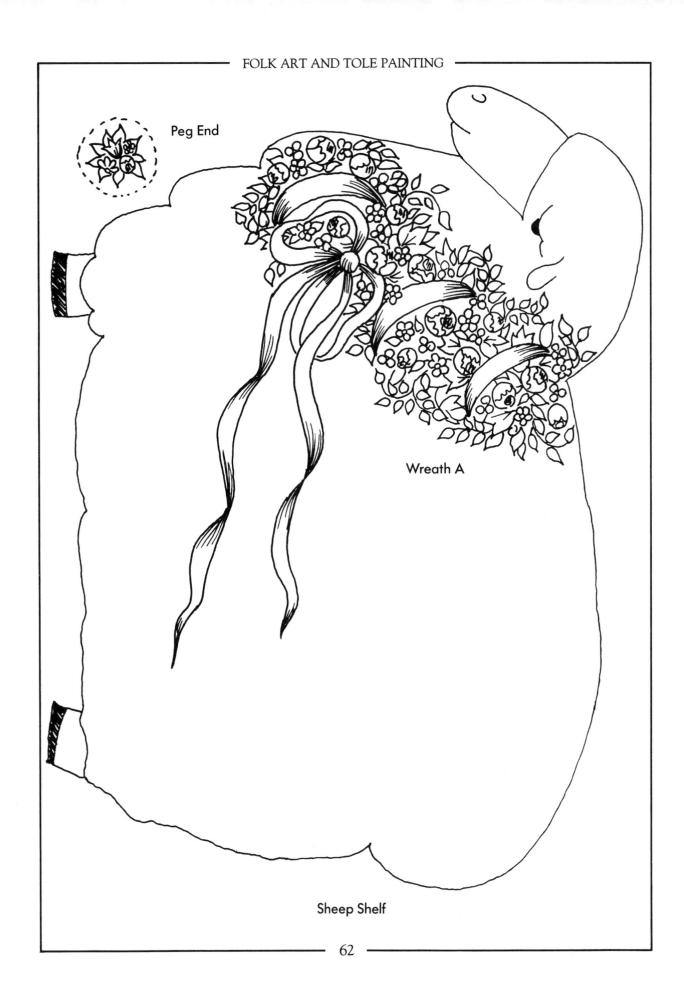

Peg End

Wreath A

Sheep Shelf

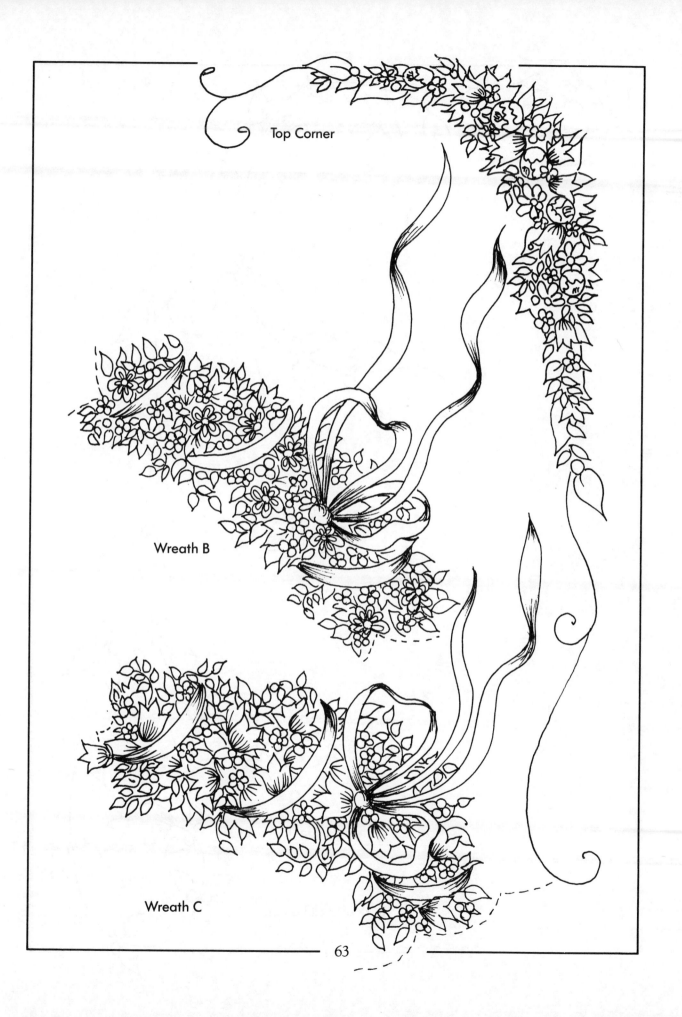

Top Corner

Wreath B

Wreath C

Overlap pattern sections for continuity.

Back of Shelf Pattern

COLOUR CONVERSION CHART

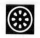

JO SONJA ARTIST'S COLOURS	MATISSE	DECOART AMERICANA	ILL. BRONZE COUNTRY ACCENT	DELTA CERAMCOAT	FOLK ART
Carbon Black	Black	Ebony Black	Soft Black	Black	Licorice
Provincial Beige	Raw Umber + White	Warm Neutral + Dark Chocolate	Wild Honey + Raw Umber	Territorial Beige	Butter Pecan
Fawn	Ash Pink + Burnt Umber	Mauve	Vic. Mauve + Raw Sienna	Bambi	Chocolate Parfait
Brown Earth	Burnt Umber	Dark Chocolate	Raw Umber	Brown Iron Oxide	Coffee Bean
Jade	Antique Green	Mint Julep Green	Village Green	Leprechaun	Bayberry
Green Oxide	Chromium Green	Leaf Green	Green Olive	Seminole	Fresh Foliage
Pine Green	Hookers Green	Forest Green	Pine Needle Green	Forest Green	Green Meadow
Teal Green	Spruce	Evergreen	Deep Forest Green	Dark Forest Green	Parrot Green
Sapphire	Cobalt Blue + White	True Blue + White	Soldier Blue + White	Liberty Blue	Blue Ribbon
French Blue	Antique Blue	Blueberry	Stoneware Blue	Nightfall	Denim Blue
Storm Blue	Phthalocyanine	Navy Blue	Liberty Blue	Dark Night	Indigo
Ultramarine	Ultramarine Blue	True Blue	Pure Blue	Ultra Blue	Ultramarine
Yellow Light	Cadmium Yellow (Light)	Lemon Yellow	Sunkiss Yellow	Bright Yellow	Sunny Yellow
Turner's Yellow	Yellow Mid	Cadmium	Dijon Gold	Yellow D	School Bus Yellow
Yellow Oxide	Yellow Oxide	Mink Tan	Mustard Seed	Antique Gold	Harvest Gold
Raw Sienna	Antique Gold + Burnt Umber	Antique Gold	Tumbleweed	Raw Sienna	English Mustard

JO SONJA ARTIST'S COLOURS	MATISSE	DECOART AMERICANA	ILL. BRONZE COUNTRY ACCENT	DELTA CERAMCOAT	FOLK ART
Gold Oxide	Terra Cotta	Terracotta	Brick	Terra Cotta	Pumpkin Pie
Napthol Red Light	Napthol Scarlet	Cadmium Red	Jo Sonja Red	Fire Red	Christmas Red
Napthol Crimson	Napthol Crimson	Berry Red	Pure Red	Napthol Crimson	Calico Red
Red Earth	Red Oxide	Georgia Clay	Pennsylvania Clay	Red Iron Oxide	Rusty Nail
Indian Red Oxide	Burnt Sienna + Burgundy	Rookwood Red	Fingerberry	Candy Bar	Chocolate Cherry
Burgundy	Burgundy	Crimson Tide	Bordeaux	Mendocino	Raspberry Wine
Plum Pink	Burgundy + White + Black	Raspberry	Fingerberry Red + White	Dusty Mauve	Raspberry Sherbet
Opal	Ash Pink	Mauve + White	Vic. Mauve + Wild Honey	Misty Mauve	Cotton Candy
Smoked Pearl	Antique Gold + White + Burnt Umber	Sand + White	Off White + Mustard Seed	Sandstone	Tapioca
Warm White	Antique White	Snow White	Off White	Light Ivory	Taffy + White
Titanium White	White	Whitewash	Whitewash	E. White	Wicker White